A Fantasy Artbook & Tabletop RPG Phrasebook

THINGS HEROES SAY

Bryn G. Jones

Andrews McMeel
PUBLISHING®

CONTENTS

Hello, and welcome to *Things Heroes Say*. I'm Partheno, Goliath Fighter of the Ninth Realm and also Bryn's longest-standing fantasy RPG character. I'm also based on a self-portrait by classical painter Anders Leonard Zorn.

My uncle asked me to teach my cousin, Petit Phil, how to climb. We ventured up into the mountains of my homeland, and unfortunately, I made a mistake when tying the rope. Petit flew off the mountain so fast that when he landed on a sharp area of rocks, he turned to dust. The elders in my village forced me to wear the mask of shame. I fled the village and stumbled upon a group of adventurers—a wizard turtle, a crippled old man, and a pyromaniac elf.

Dungeoneering with this crew led to the creation of *Things Heroes Say*. These phrases will break the awkwardest of awkward silences and will inspire you to add that killer tagline, an absolute banger when the time should arise. Who knows, you may even get a laugh out of your gamemaster.

I hope you like the art, and I hope you have fun.

Watch out for those big ol' drags,

Partheno x

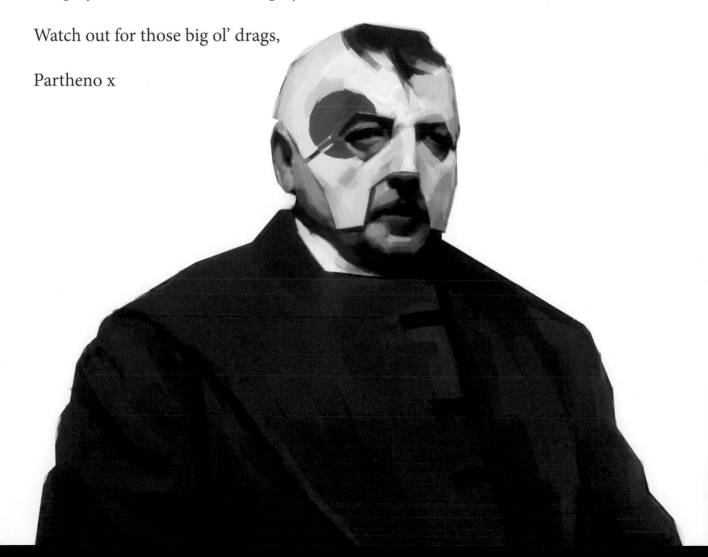

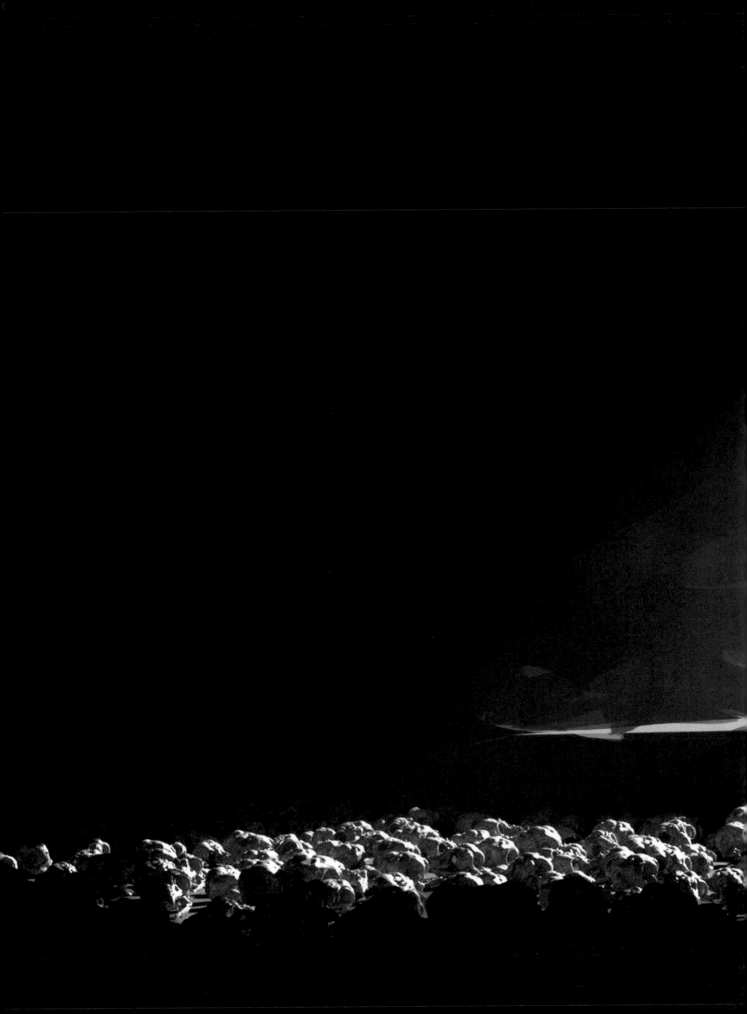

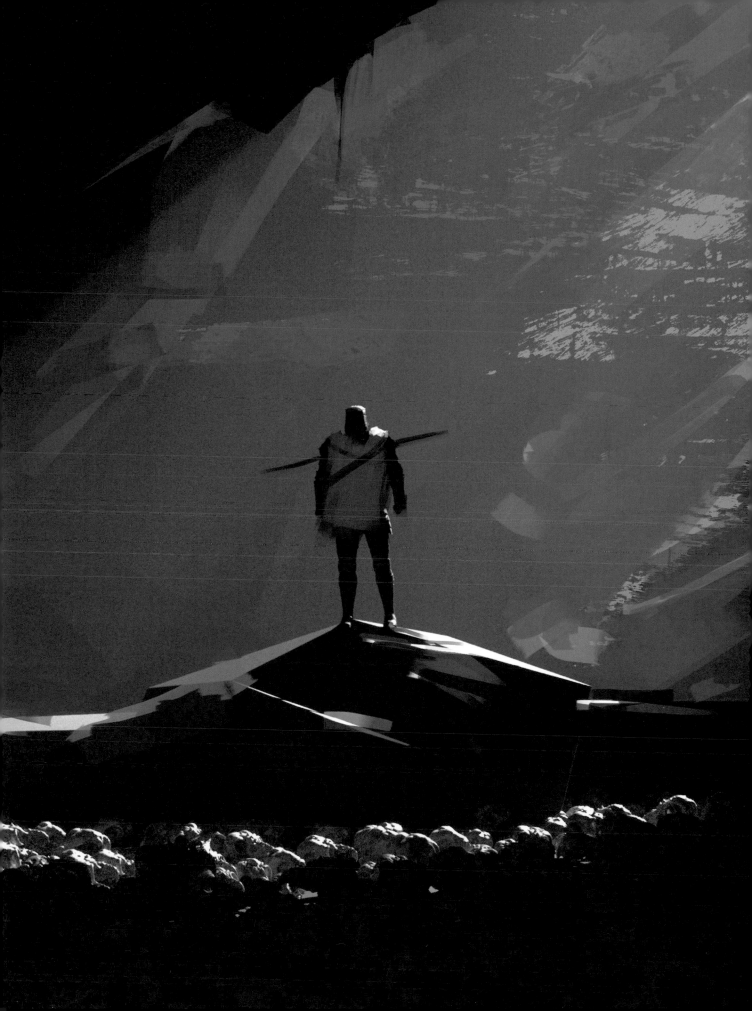

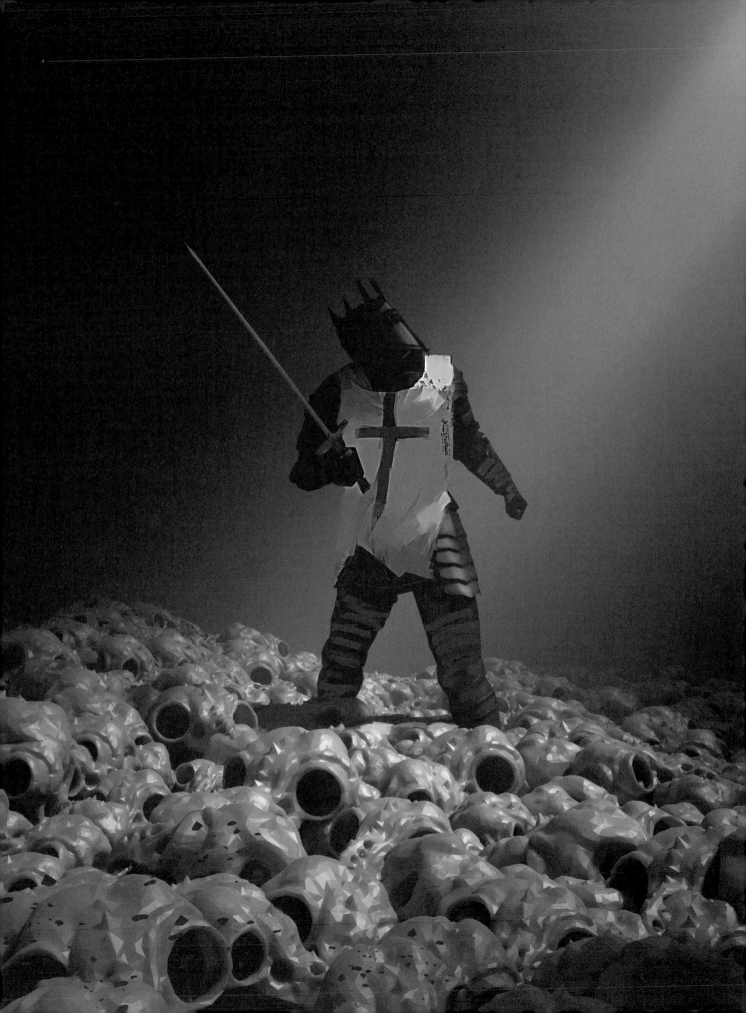

IF IT ALL KICKS OFF, STAND BEHIND ME. I'LL BASH THOSE DRAGS.

SOMEBODY GET THE LIGHTS; I CAN'T SEE A THING DOWN HERE.

Do you smell that? Can't be good.

THIS IS JUST LIKE THE LAST ONE. WHEN WILL THIS NIGHTMARE END?

My cousin told me stories of this place when we were children. I was not afraid back then. But then again, I never saw the dungeon's true face.

DAD . . . IS THAT YOU?

TAKE WHATEVER YOU CAN FIND. THE OWNERS OF THIS PLACE CLEARLY HAVE NO DESIRE TO TAKE CARE OF THEIR POSSESSIONS.

If I die in this place, bury me in the fields where I buried my dog. There's a good boy.

If I had a gold coin for every time I went into a dungeon, I'd be able to take us all on vacation. I know a mountain range in the north. No drags. No demons. And a really nice bar where everyone knows your name.

I wonder if they have a room with a view. Hahaha. Jokes.

I've got dibs on the sweet loot.

Whoever has the biggest shield or the zappiest magic wand—you're walking at the front of the group for sure.

I sense a deep disturbance in this place. An irregularity in the firmament. Guard yourselves, my wizard brothers and sisters.

Oh, I've seen loads of places like this. It's actually why I became a wizard. The dungeons always keep you guessing, y'know. And to think I could be stuck behind a table counting coins for some rich guy. Nope, not me . . . dundge, dundge, dundge, all day.

In this place, my sword aches for demon blood.

Whose idea was this?

I dream of walking through fields. The sun grazing my skin and the wind blowing through my wild beard. A place where I do not have to fear. The golden heavens that I call home.

If there's a big ol' drag in this place— you bring the thunder; I'll bring the lightning.

Echo . . . echo . . . echo . . . I love doing that.

Who do you think built this place? It has a familiarity. I feel that we are in some way connected to its architect.

I'm not too sure what to make of this desolate hole. Although it gives me the impression that it's the last place we'll see.

Oh hellish cave of eternal darkness, sing to me. Tell me your secrets, and share with me your magic.

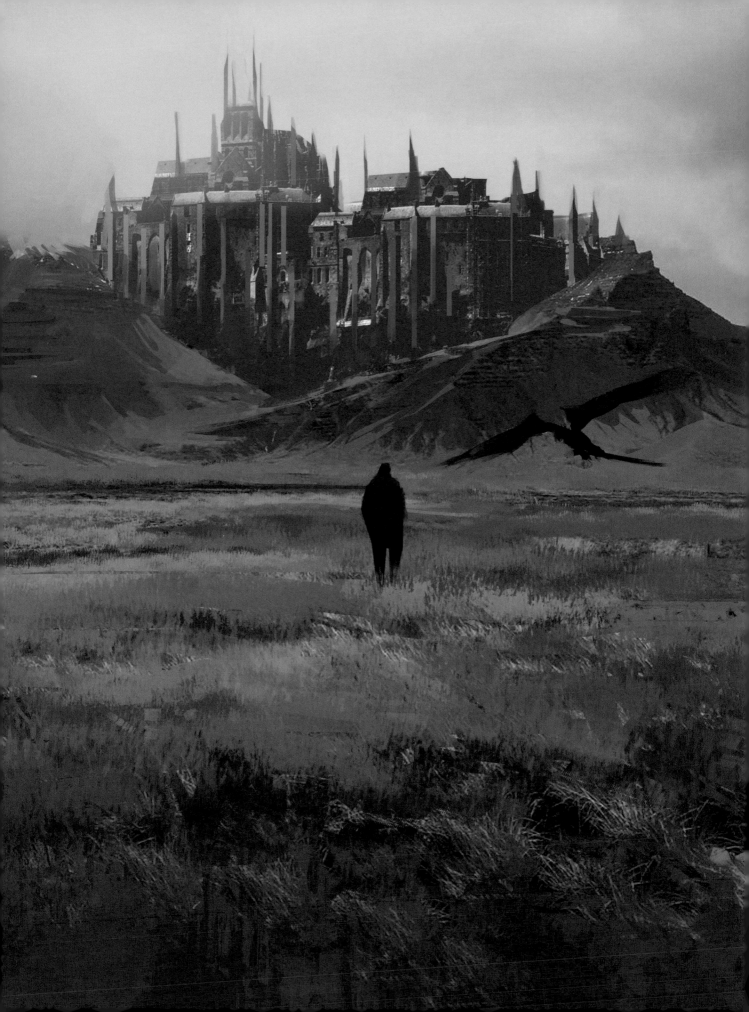

WHEN SOMEONE UNKNOWN APPROACHES

My brother Propriatus had his purse snatched by some-one when he was a teen sapling. A fire for vengeance burns a path of destruction inside me. Do you think this might be the thieving monster, the firestarter?

If he starts with "Hi, I'm so-and-so," he's secret police.

I SAY WE GET STRAIGHT IN THERE—ROUGH HIM UP A LITTLE AND MAKE HIM TALK. THAT WAY WE HAVE LESS CHANCE OF GETTING SCREWED OVER.

I'M NOT ONE TO JUDGE A PERSON SOLELY ON THEIR APPEARANCE . . . BUT THAT WOMAN LOOKS LIKE SHE SUMMONS DEMONS.

You can always trust someone who hangs out in a dungeon.

Why is he looking at me like that?

Don't like him.

If you're looking to trade with us, we have the gold, but we want value. We don't vape our pape, if you catch my drift.

I have met many folks on my travels through the desert plains of my homeland. Greetings, wanderer, let us share our knowledge and resources with you.

Fancy that, someone else is here.

I'm not gonna beat around the bush. Twenty years ago, when the riots of Friars Herald raged through our streets. Where were you? Did you partake in the burning?

Hahaha Ryan. Long time, my friend.

WITH A ROBE LIKE THAT, I SUSPECT THIS DUNGEON DWELLER PERTAINS TO THE ORDER OF THE DEAD EAGLE. I'VE DEALT WITH PEOPLE AND ANIMALS LIKE THIS BEFORE. LET ME DO THE TALKING.

Traveler. If that's what you are. Be warned. This band of brothers and sisters, as kindhearted as we appear, will not hesitate to crush you into ash. Proceed with caution. What can you do for us?

Boundaries, guys. I'm not opening the gates to my front garden for this joker.

Oh . . . shoot, I recognize that guy. I think we went to school together. So awkward. Don't make me say anything.

INTRODUCE YOURSELF FROM THERE, WENCH; DON'T GET ANY CLOSER.

RUBS HANDS TOGETHER LET'S TALK BUSINESS. WUT YOU GOT?

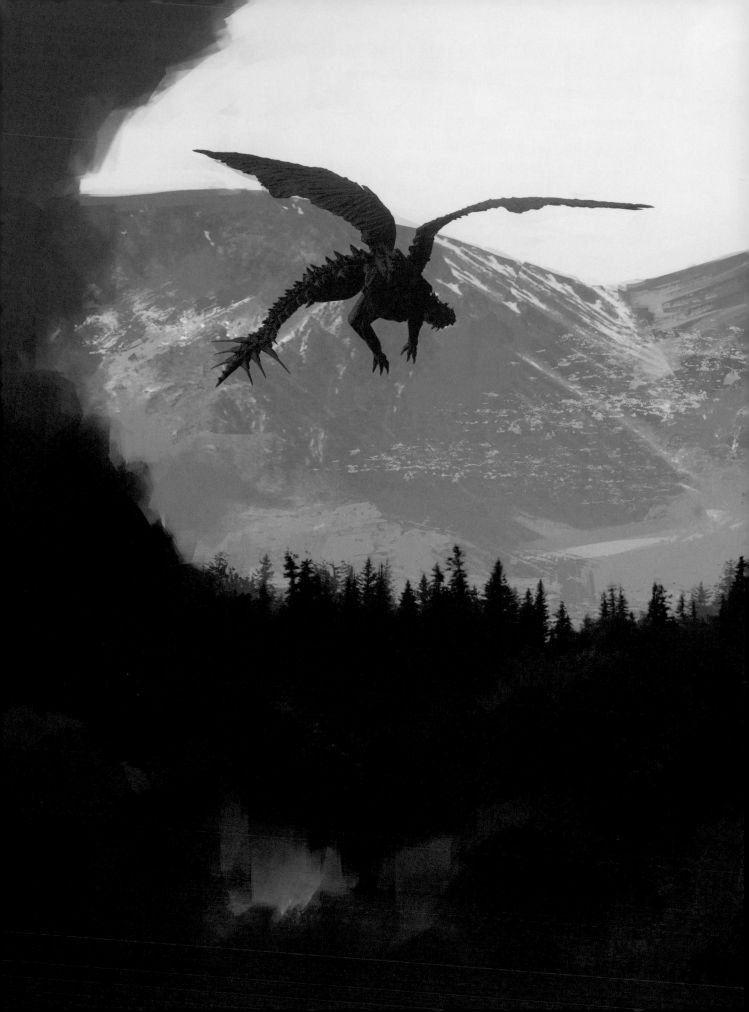

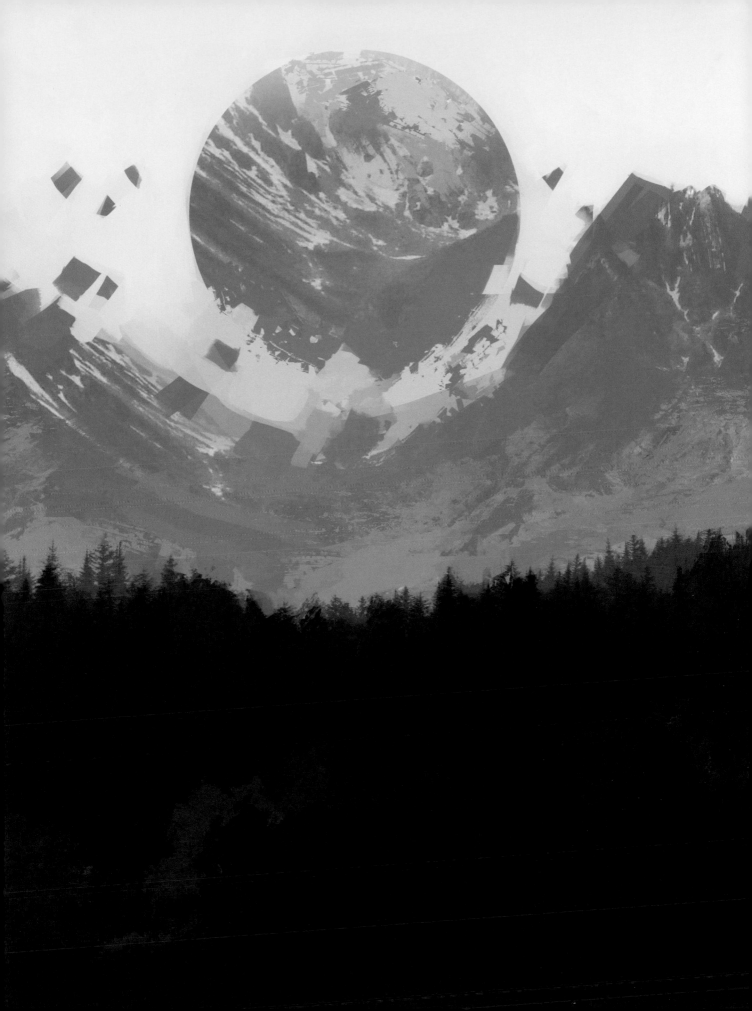

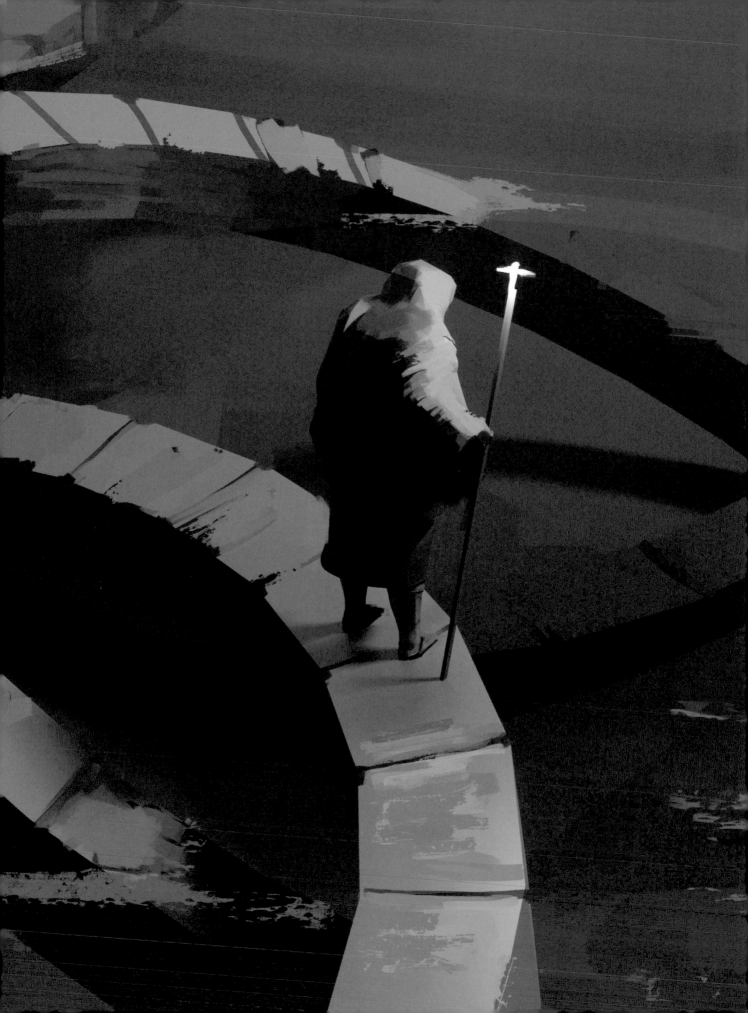

IT IS STAINED WITH DRAGON BLOOD. DO NOT LET THESE WATERS CURSE YOU.

I HAVE THREE TECHNIQUES—FRONT CRAWL, BACKSTROKE, AND DRAGON CRUSH, ALTHOUGH I'M NOT AS STRONG WITH DRAGON CRUSH.

I say we throw our clothes across, embrace the cold rush, and pray for no demons.

IT'S A WARM ENOUGH DAY; I DON'T SEE ANY PROBLEMS WITH THIS.

Oh sacred oracle of Chimarika, why are you punishing us? Surely there is a way across more suited to an honest servant like me. Chiiiimarikaaaaa . . . I beloooongg to youuuuu.

Growing up we had a stream in our back garden. I used to make toy boats out of small bits of wood. It was a good time of my life . . . before the burning started.

I SWIM LIKE AN EAGLE.

It is not the crossing of the water that is the issue here; it is the drying of the clothes and the warming of the bodies. Let's not cross until we know we can build a fire.

HOLD ON ONE MOMENT WHILE I INFLATE MY PIG'S INTESTINE LIFE VEST.

Are you certain this is the way? Usually, there is a path or road and then a bridge.

IF WE USE THESE EMPTY BEER BOTTLES I'VE BEEN SECRETLY COLLECTING, WE WOULD PRETTY MUCH HAVE A BOAT.

My brothers and I would often cover ourselves in leaves and makeup and wade through rivers up to our necks. We were the best of the best—a band of heroes.

IF WE GO BACK, WE ARE COWARDS, BUT IF WE GO FORWARD, WE ARE LIKE DROWNED RATS.

LET'S NOT RUSH INTO ANYTHING; I'M SURE WE HAVE TIME TO FASHION A RAFT.

How long do you think this will take to dry up?

I was worried it would come to this.

CROSSING ONCE, FINE. CROSSING TWICE? I'M NOT SO SURE.

Fear is the heart of darkness—follow my lead and we will laugh until we are dry.

Someone hold me upside down and dunk my head in so we can gauge how deep this is.

IT RAINED HEAVILY TWO NIGHTS AGO . . . NOW IT ALL MAKES SENSE.

Orcs don't float. Tell me that's a rumor, but I ain't taking any chances.

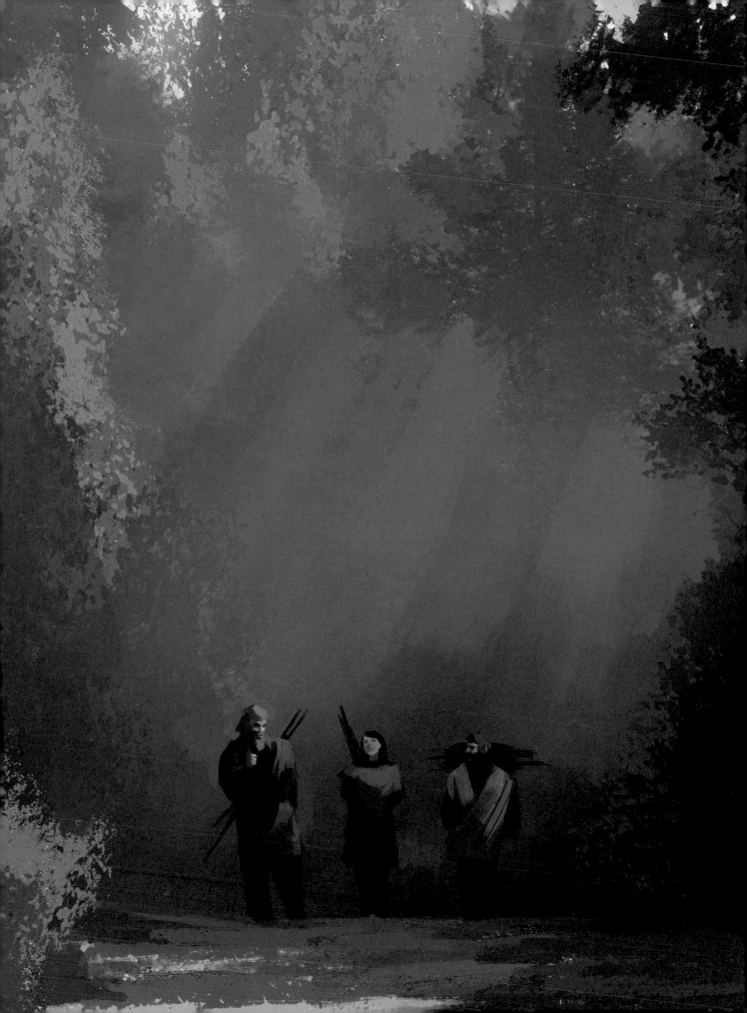

My feet are burning like the coals of Dark Shaman Raz-Man-Goot.

I'm soaked to the core in sweat. I'm pretty sure it's mine. Let me just check . . . yeah, it's mine.

WHAT'S YOUR FAVORITE VINE?

The last time I was walking through here, there was a sign saying "No Orcs or Goblins." My friend Ronny had to turn around and go home—so brutal.

I DON'T KNOW, BUT I'VE BEEN TOLD . . . MY WIZARD FRIEND IS A BILLION YEARS OLD.

I like to count the leaves as I walk through the woods. One million and one, one million and two . . .

IF ANYONE WANTS ME TO CAST "CONVEYER BELT," JUST LET ME KNOW.

There's a company on the other side of the ocean developing self-driving horses. It'll be years before they become available to folks like us.

THERE'S A CARVING OF A DRAGON OVER THERE WITH NAMES SCRATCHED INTO IT. PROBABLY MEANS NOTHING.

THE ANGEL OF DEATH JUST TAPPED ME ON THE SHOULDER AND POINTED AT YOU. SOMETIMES THESE THINGS ARE A SIGN.

I've been walking my entire life—like a baby giraffe.

If things keep going this well, we'll be set for life.

I'VE NEVER HAD THIS MANY FRIENDS BEFORE. MY MOM WOULD BE SO PROUD.

AT THE NEXT CAMP, I'M GONNA COOK US A KILLER LEEK AND POTATO SOUP, JUST YOU WAIT!

These trees are frightfully foreboding . . . Love a good foreboding tree.

Dear diary, me and my pals are off on a great adventure. What waits for us at the next milestone? What drama will we be thrown into? . . . *long sigh*

Would it be OK if we dropped the pace a little? My legs are half the size of yours.

I have the BEST fruit and nut mix. You should totally try some; I'll get it out right now.

MY COUSIN AUDREY DIDN'T WALK ANYWHERE; SHE FLEW AROUND ON THE BACK OF A GRIFFIN. LUCKY F*&^%£* B*&^%.

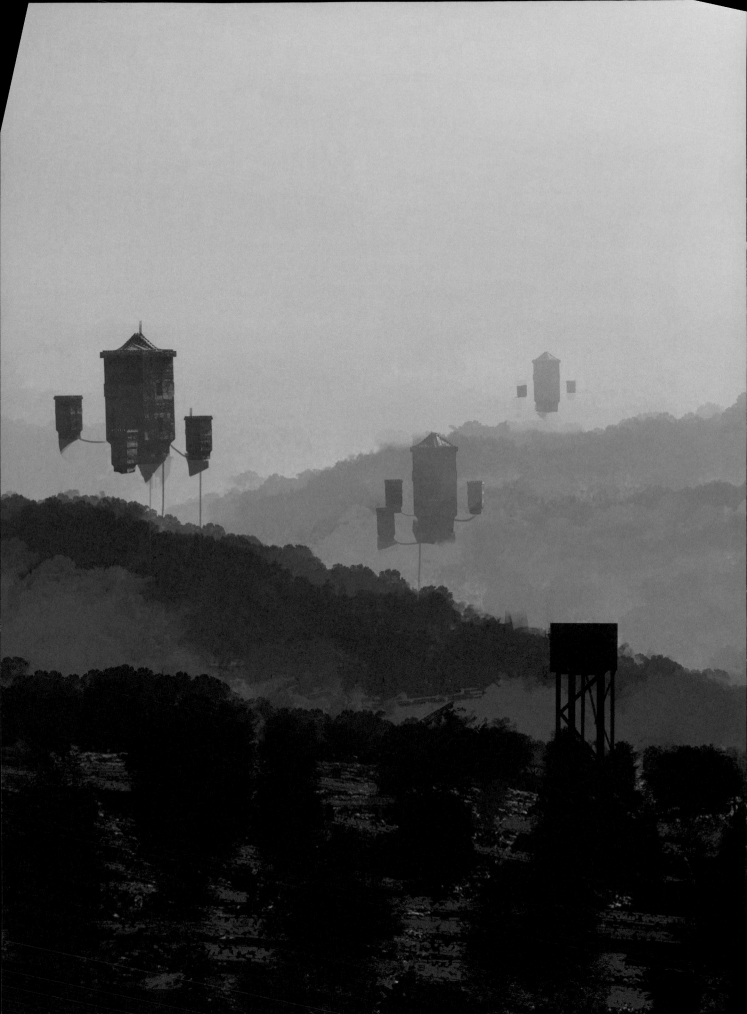

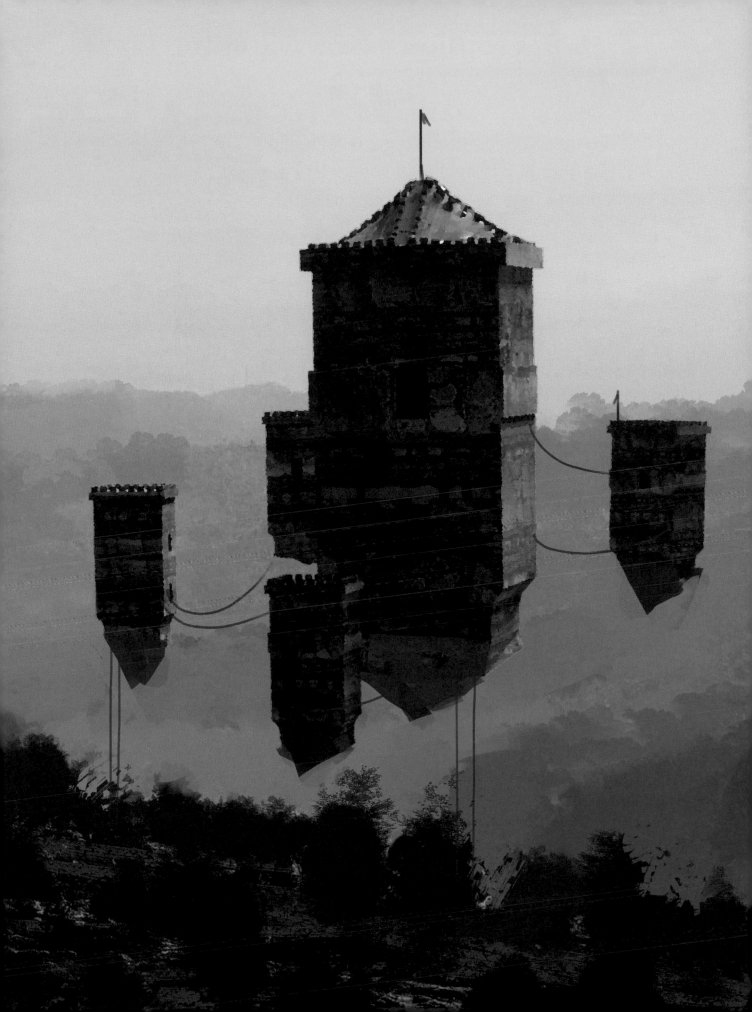

My rations . . . they've all suddenly gone stale . . . What . . . is this place?

I usually take these things pretty casually. I'm sure we'll turn up in the right spot sooner or later.

ASK YOURSELF NOT, WHERE THE HELL ARE WE. ASK YOURSELF, ARE WE GOING TO BE DEVOURED BY A BEAST BECAUSE OF OUR PRESENCE HERE? I LIFT MY HANDS TO THE GODS, AND I LET THEM DECIDE. *SINGS* COME TO MEEEEEE . . . DRAGON OF THE NIGGGGHTTTT . . . RIGHTEOUS AND FOUL . . . ANGRY AND BRAZENNNNN.

I guess if we didn't know where we were AND were being attacked from all sides, THAT would be a much greater cause for concern. I say we set up a little camp then take a look around to see what we're working with.

It's times like this that you're glad you're carrying an ax, two swords, a bow and arrow, and a potion.

If we used a photo-reactive film and placed it behind a tiny hole—an aperture—then we could get a picture of ourselves in this place and show our friends and family. How's my hair—is it OK?

THIS . . . THIS IS NOT ON MY MAP. ARE WE IN A NEW PLANE OF EXISTENCE? ARE WE ON A UNIVERSE PARALLEL TO OUR HOME WORLD? THIS FORM OF FEAR IS NEW TO ME. A MAP . . . I NEED A NEW MAP.

WHAT A PICKLE THIS IS, RICHARD.

THIS PLACE SUCKS.

IS THERE A LITTLE DRAWING OF THIS PLACE ON THAT MAP OF YOURS? OR IS THERE ANY CHANCE THIS PLACE IS FAMILIAR TO YOU? BECAUSE TO BE QUITE FRANK, I'M FREAKING OUT.

Look . . . the stars. That one is shaped like a dove. We're gonna be fine, my friends.

I HAVE SEEN THIS PLACE IN MY NIGHTMARES! IT'S REAL! . . . OH GOD, IT'S REAL!!!!!

MY DAD USUALLY ROCKS UP AND TAKES ME HOME RIGHT ABOUT NOW.

My uncle was a travel writer. The people of my town got jealous and executed him. Oddly, he still seemed quite pleased with himself.

YOU GUYS ARE STILL INCREDIBLY CONDESCENDING, SO WE CAN'T HAVE GONE TOO FAR.

I THINK I'M GONNA VOMIIIT.

It appears we have reached a crossroad on our journey. Look . . . one, two, three, four . . . yeah, a crossroad.

Looks like another land to conquer. All hands in the middle, guys. One, two, three, SLAYERS!

WIZARD STICKS, WORK YOUR MAGIC. FIGURE OUT WHERE WE ARE AND WHERE WE SHOULD GO.

Strangely familiar . . . discomfortingly alien.

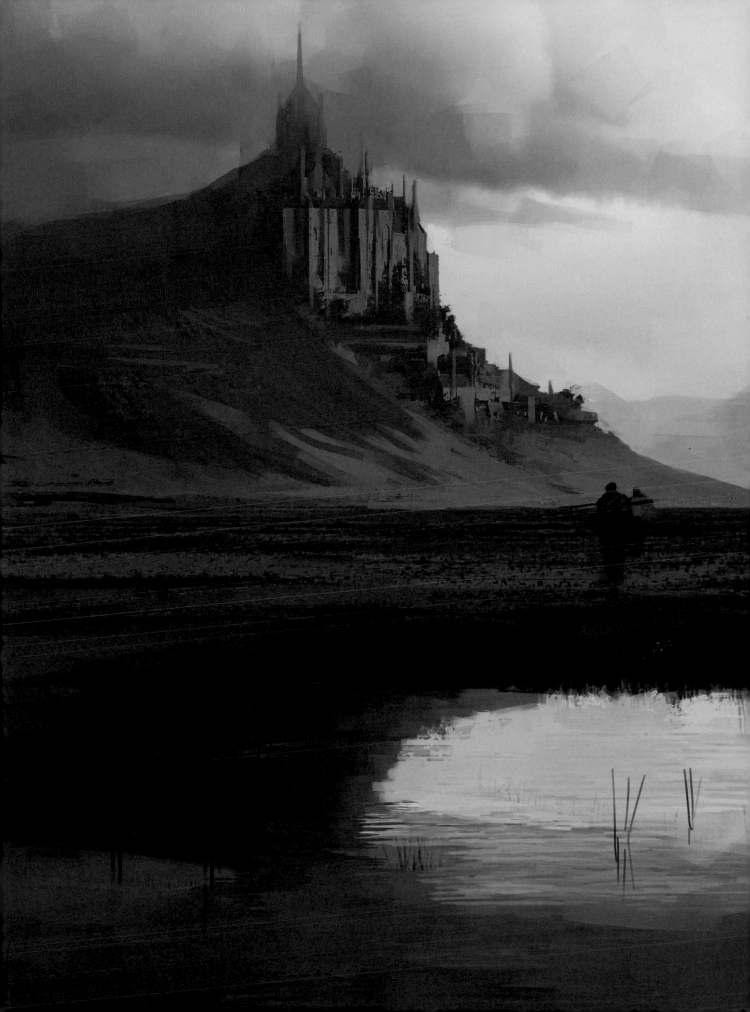

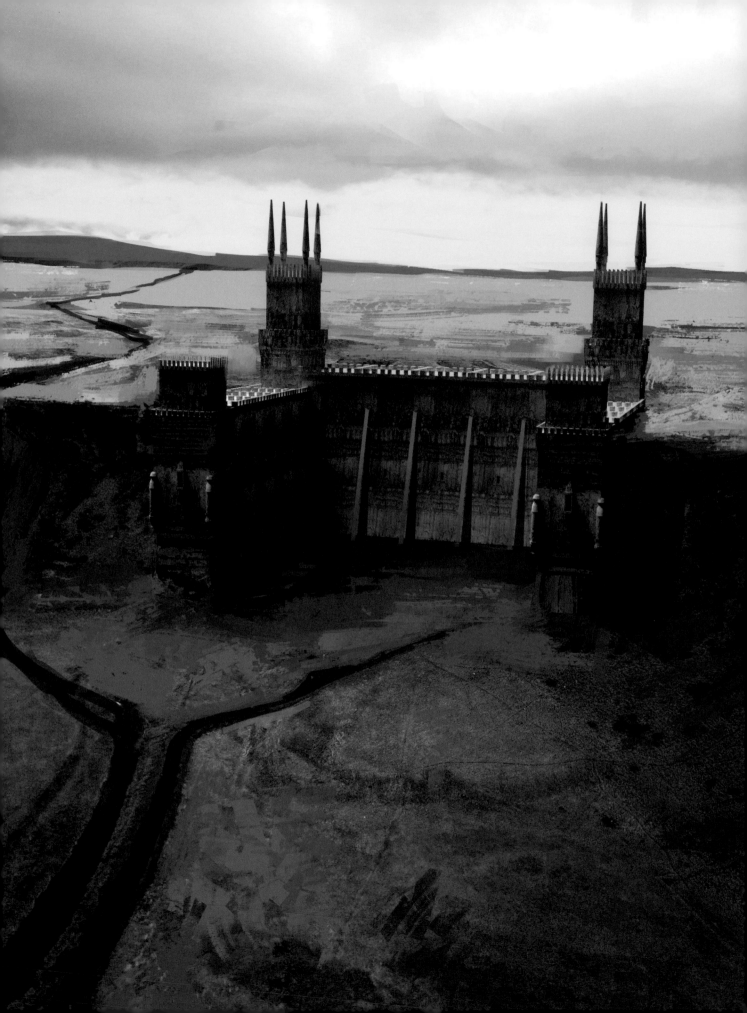

I WISH MY FATHER HAD SOMETHING LIKE THIS THAT NIGHT HE GOT LOST ON THE MOUNTAIN.

I met a guy who made a living from drawing maps. The funny thing is none of them were real—a total fantasy.

IT'S NOT TO SCALE. SO AMATEUR.

This . . . this is how people get rich.

Yeah . . . this is all pretty standard stuff.

I'm gonna need a wizard to cast "street view" on this.

I'M NO PIRATE, YOU GUYS, BUT IT DOESN'T SAY ANYTHING ABOUT NOT MAKING DUPLICATES OF THIS.

LOOK AT THAT. WHO KNEW. WE WENT AROUND IN A CIRCLE FOR FIVE DAYS.

They should really put a warning sign on the area where those acidic gloop monsters tried to dissolve us.

Sigh . . . This reminds me of the first time I was handed a map.

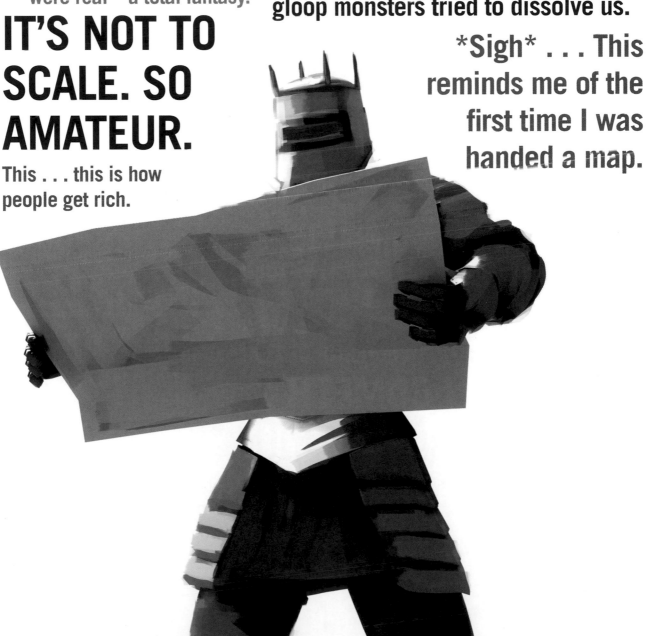

What did I say, ladies? We made it.

NOT A DRAG IN SIGHT, BOYS!!

This is where the dragon sleeps. This . . . is where the dragon dies.

OH MY GAAHHHHH. This reminds me of that time I got back to the farm and my family was all still alive.

This is all very exciting. I'm sure the rest of you are feeling pretty jazzed about this. But I would just like to take a short rest over there—a quick nap if that's OK.

PLEASE, GODS OF THIS UNIVERSE, WE MUST HAVE LEVELED UP BY NOW. SURELY!!!!

Awwwwwrrrrr . . . I left my keys at home.

The people of my village will be proud. When I return as champion, they will also be obedient.

GREAT, MERCIFUL BOSOM OF QUEEN LAHMANRIA: HAVE YOU EVER SEEN ANYTHING LIKE IT?!

It was worth staring death in the face to reach this place with you, my friends. Our arrival is the crown, our throne—companionship.

It's a shame we can't all be here. I would like to take a moment to kneel and give thanks. *Cries* Oh, the soldiers who fought by my side, be a guiding light amidst the darkness.

It's not one of those places that's closed on a Sunday?

THESE M*$£^&* F*%$£# TWO-TOED S#$*&{- D*&%^ BETTER SERVE ME A GOOD CUP OF TEA!

I COMETH UNTO THOU.

IF THE REST OF OUR JOURNEY IS ANYTHING TO GO BY, I'D SAY WE'RE LIKELY TO GET IN A FIGHT HERE.

THIS IS THE PLACE IN THAT OIL PAINTING I WAS TELLING YOU ABOUT. WITH THE STONES AND THE ARCHES AND STUFF. I NEVER KNEW . . . FANCY THAT . . . I NEVER KNEW IT WAS A REAL PLACE.

The angels have carried us.

WELL, WE'VE SET FIRE TO EVERYTHING ON OUR PATH SO FAR. LET'S MAKE THIS A ROYAL FLUSH.

I KNEW WE WOULD MAKE IT, MY BROTHERS AND SISTERS! SING THAT JOYOUS HYMN OF ELATION! OHHH MY LOVVVVEEEE . . . HIGH ABOVE UUUUUSSSSS.

It's really not how I imagined it.

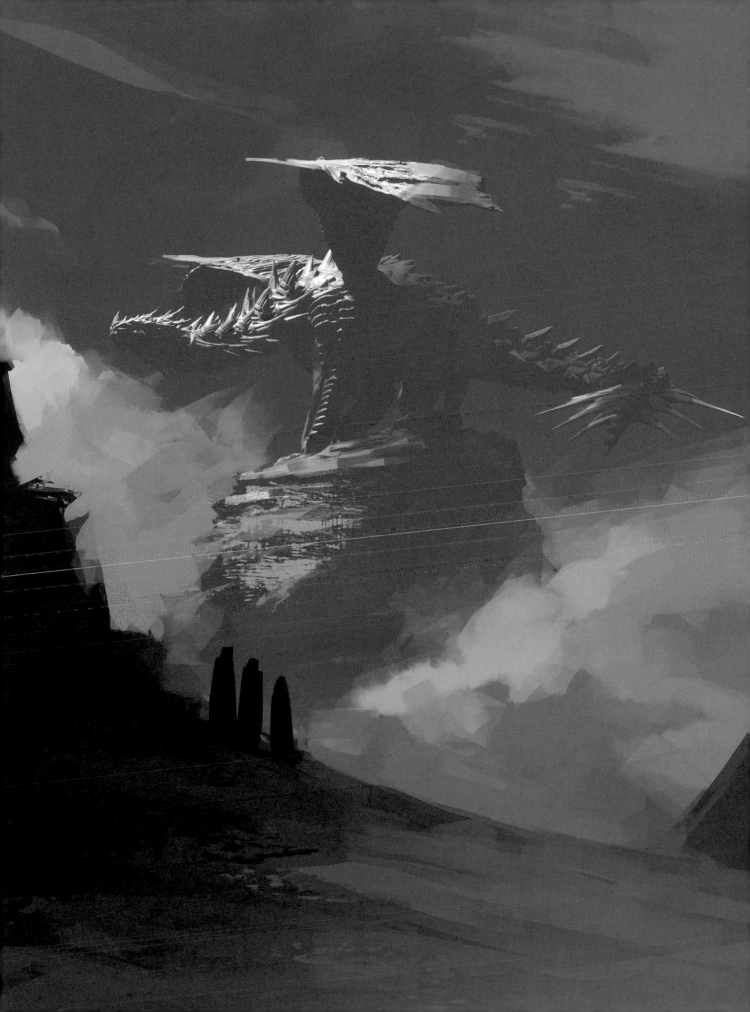

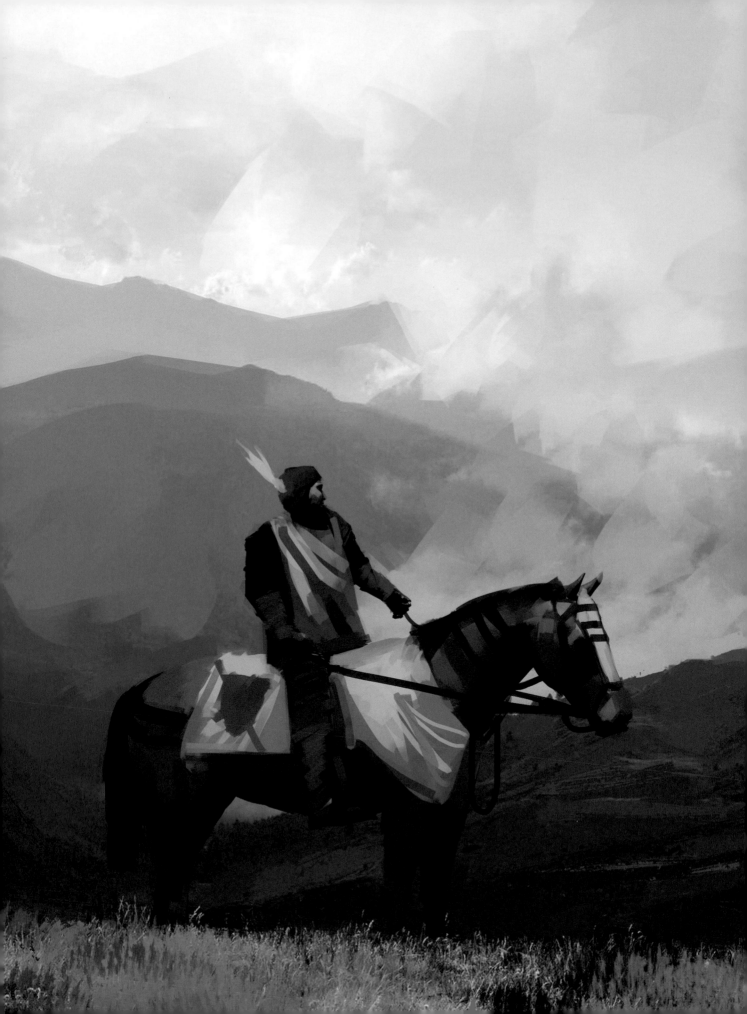

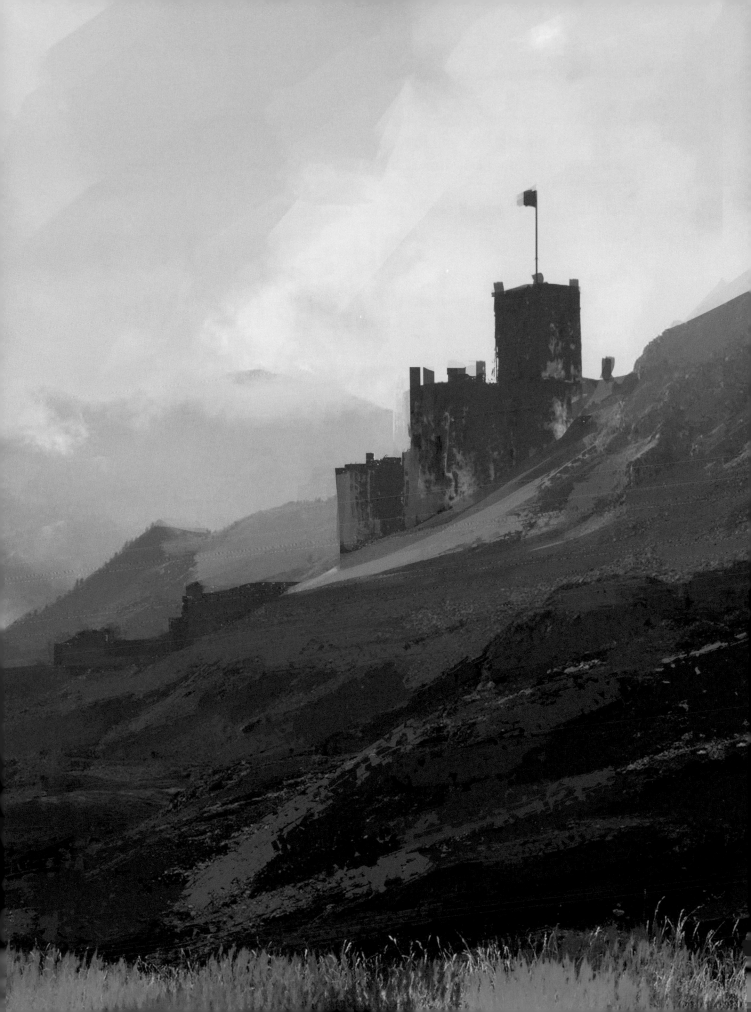

It's so easy to distance ourselves from folks who study and practice magic. To cry witchcraft and banish the sort like you in fear, or in hatred, or a strange combination of the two. I knew when you fought off that beast by my side; I knew you had a good heart. Your magic is strange to me, but your friendship, that's something I've always known. My crippled, wrinkly dungeon brother, I'm with you to the end.

Was that you or the wand?

I HAVE WAITED MANY WINTERS TO GAZE UPON SUCH AGED BEAUTY. YOUR SKIN IS LIKE A NOVEL—A TALE WOVEN TO WARM ANY DUNGEONEER'S COLD, HOPELESS HEART.

OH SING TO ME, MAGIC GLOWING RING-WIZARD.

Wouldn't it be cool if one day we could talk to each other from a distance and see each other's faces? Impossible, I know, but it would be so cool.

BRO, HE'S SAYING SH%* ABOUT YOUR GIRL HERMIONE. ZAP HIS ASS, YO!

That cloak looks great on you. Own it, old man. Own the throne.

My spell book brings all the boys to the yard, cantrip; it's better than yours!

If I carry you on my back, we would be like a lightning god-tank.

What's cooler than being cool? Chill touch! I said, what's cooler than being cool? Chill touch!

I read a book about a witch like you. Her powers continued to grow stronger until they became out of control. If that happens with you, I'll be ready on that killswitch, don't you worry.

Neat trick, magic man, with the thunder and the lightning; you'll need it when big papa wolf comes a-scratchin'.

There is a temple in the city from where my people fled. In the heart of the darkness, the heart of the temple, lies a dark magic that no man has ever vanquished. If I can pay your wage, your price, will you join me on the ultimate journey and battle against evil? After this one.

I appreciate you turning those undead panthers into ash, but I have to ask when those eagles ripped apart Joffers . . . could you not have used that then?

DON'T BRING IT BACK TO LIFE! THAT'S DISGUSTING. WHAT'S WRONG WITH YOU, RICHARD.

If you point that thing in my direction ever again, I'll snap it with my ax and bury it with the sharp edge of my shield. I'll break your little wooden body in half as well.

Does that spell always make those cool colors, or are you adding a bit of style? A bit of flair?

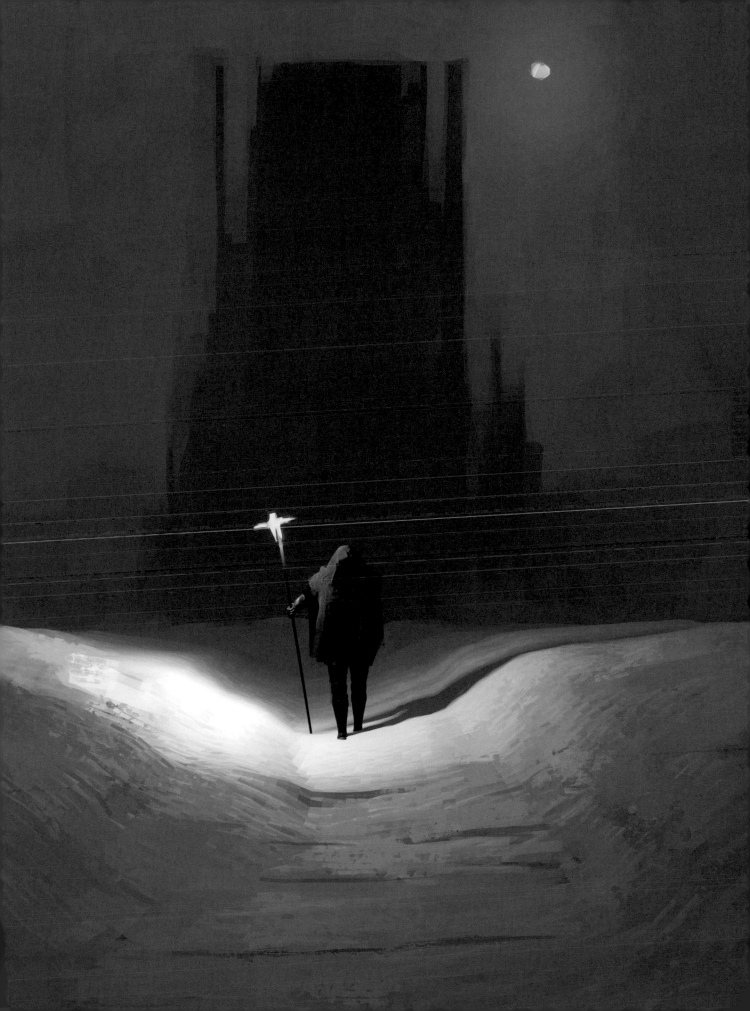

THINGS TO SAY BACK TO PEOPLE

Wow. That's incredibly harsh considering everything we've been through recently.

WELL . . . YOU WOULD SAY THAT, WOULDN'T YOU?

In all of my years spent wandering the plains of this mysterious land, I have never heard anything so intriguing. Would you like to join us on this quest and share with us your fine culture?

PRETTY STRONG WORDS COMING FROM SUCH A DAINTY FRAME, WIZARD-MAGE.

I could ask you the same question.

What's your price? How much gold?

YOU SHALL EAT THOSE WORDS, OR YOU SHALL DINE ON THINE OWN TEETH.

It pains me to hear this. My father and mother warned me before I left. I should have listened. I am ashamed.

That sh&% just bounces right off me.

Please direct any insults or complaints to my elf secretary. Although I have to warn you—she doesn't care either.

OH YEAH . . . TELL IT TO THE JUDGE. YOU'RE UNDER ARREST.

I like to write things like that down in a handy phrase book.

Mwahahahaha typical citadel dweller, you're all the same.

When you meet death, he'll say the same thing to you as he did to that big ol' drag that popped up—shoulda kept your mouth shut.

Could you elaborate on that? I'd really like to know what I'm working with here.

THOSE ARE SOME MIGHTILY BROAD SHOULDERS, YOU SQUEAKY LITTLE MOUSE-HALFLING.

GIVE ME A SECOND WHILE I WRITE THAT DOWN. *REPEATS WHAT THEY SAID IN A QUIETER VOICE*

TEN OUT OF TEN FOR THE SARCASM. COME TO THE MEDAL CEREMONY TOMORROW, WHERE WE'LL BE HANDING OUT SARCASM MEDALS.

That's exactly what the last dwarf said to me. Do you wanna see where he ended up? It's pretty dark. Oh . . . it's pretty . . . flippin' . . . dark.

DEEP IN THE HEART OF THE DEATH DUNGEON, I HEARD THE VOICE OF AN AGED DRAGON CHANTING EVERYTHING YOU JUST SAID TO ME. THE QUESTION IS THIS; DO YOU FEED THE DRAGON WORDS, OR DO YOU FEED THE DRAGON BODIES?

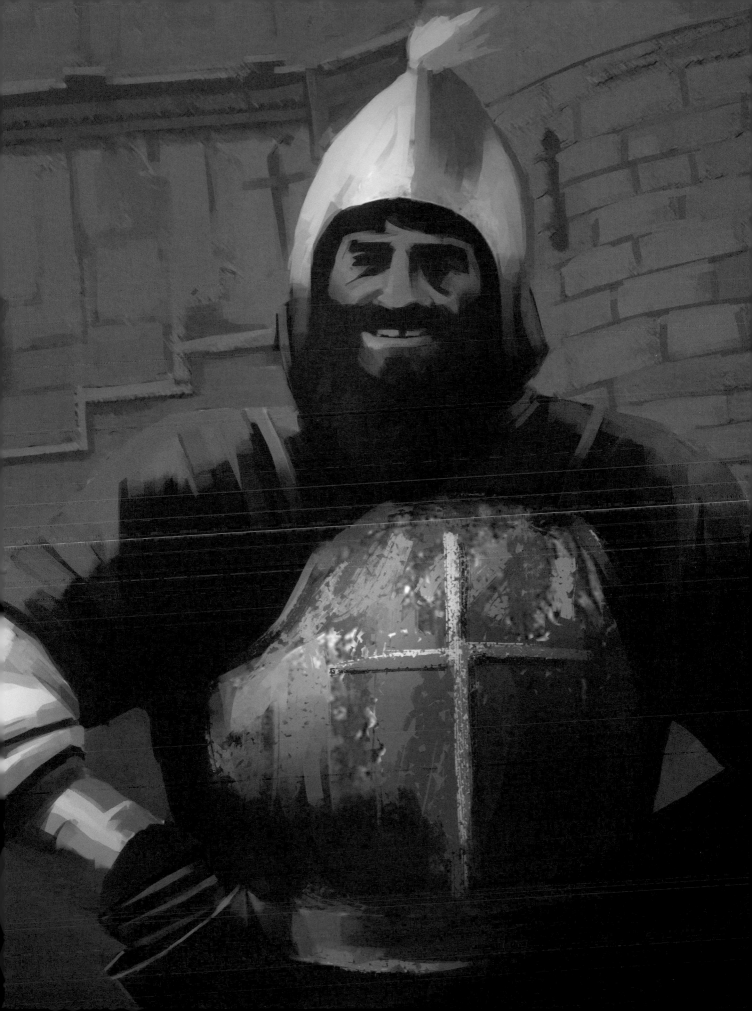

INTRIGUING, BUT IT DOESN'T EXPLAIN WHY THOSE ACID-CRYSTAL-DEMONS DESTROYED MY VILLAGE.

Sounds awful.

IS THAT WHY THOSE GOBLINS BACK THERE WERE SO SNARKY WITH US?

Desperately flips through paperwork No . . . this doesn't add up . . . this was not how it was supposed to be. Is this what was hidden all of these years? This? This is the truth that binds our fate? That holds us? No, my brother, I don't want to hear any more. NOOOOOOOOOOO.

WOULDN'T HAVE IT ANY OTHER WAY.

CAN'T YOU SEE, MY BROTHERS AND SISTERS? IT IS MERELY HISTORY REPEATING ITSELF. WHEN WILL WE BREAK THE CYCLE . . . WHEN WILL WE BREAK THE CHAINS . . . WHEEEEEEEENNNNNNNN?!!!!!

That's so good I almost want to write it down.

IT ALL SOUNDS WHOLESOME AND MAGICAL, BUT BACK THEN THEY WERE ALL DRINKING THEMSELVES TO DEATH.

I guess that's proof that things have only gotten progressively worse throughout the ages.

Wow . . . a true 101 AD hero. They really don't make 'em like that anymore.

I HAVE HEARD MANY STORIES ABOUT THIS, BUT NEVER STRAIGHT FROM THE HORSE'S MOUTH. TEACH ME. MAKE ME LEARN. WHY IS IT SO?

I flunked history. I really don't care.

I FEEL CENTURIES OF BURIED HATRED SWEATING OUT OF MY BODY. I CAN'T BELIEVE I STAND ON THE SAME GROUNDS AS THIS MONSTROSITY.

AWKWARDLY FASCINATING, MY FRIEND.

It's amazing how something that happened so long ago managed to perfectly preserve itself after being retold by countless people.

It is hilarious how people try to bury something like this, and then people are still talking about it a thousand years later.

STILL RELEVANT.

I BET WE'RE ALL RELATED TO THEM. F*^%$NG RELATIVES, AYE.

Drinking or fighting to death . . . it's not great.

That really old dude who was such a champ is totally related to me.

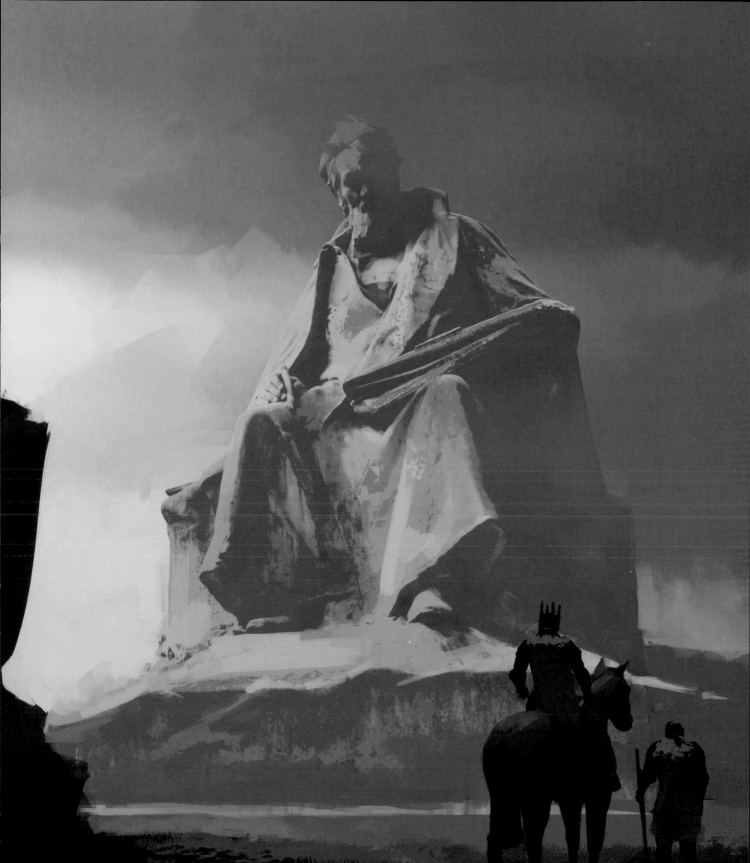

Leave this to me, boys. I've read all five issues of *Crime Scene Mountain*.

IF ONLY AN ANGEL WOULD DESCEND AND IMPART WISDOM.

AS SOON AS YOU FIND OUT WHAT THIS IS, GIVE ME THE WORD, AND I WILL BRAVE THE STORM AND RIDE MY STEED FOR A THOUSAND MILES TO WARN OUR KING.

All of our questions will be answered in death *RIPS A MASSIVE CLOUD* . . . but I ain't got time fo' that.

MY MIND IS TOO SHROUDED BY DARK THOUGHTS FROM MY PAST.

The mind is mightier than any magic.

I'M ROLLING ZEROS, SQUAD—NOT THE FOGGIEST.

SILENCE!!! PLEASE BE PATIENT WITH ME, HEROES. I MUST WORK IN TOTAL SILENCE.

I'm beginning to get the feeling that THIS ALL LINKS BACK TO THE TRAUMA I FACED DURING MY TIME AT HIGH SCHOOL!!!!

This isn't really my area of expertise, so if you don't mind, I'll be on the side eating trail mix, waiting for you to figure this all out.

IT LOOKS LIKE THIS MYSTERY IS JUST GONNA GET DEEPER AND DEEPER. TAKE FIVE, TEAM—THIS IS GONNA TAKE AWHILE.

GATHER ALL THE FACTS, MIX 'EM INTO A BOWL, AND SEE WHAT BREWS.

What is this world trying to tell us? If our fate had a voice, what would it say?

I have seen writings like this before. I do not know the exact translation, but I fear we are in great danger.

I say we chant some ritual verses and see if anything pops up.

I PACKED FOOD, SOMETHING TO SLEEP ON, AND A LOT OF ARROWS AND OTHER WEAPONS; I TOTALLY DIDN'T BRING A NOTEPAD AND PENCIL.

WE MUST GO AND RUB THE BRANCHES ON THE TREE OF KNOWLEDGE.

HMM . . . SMELLS LIKE . . . BETRAYAL.

The way these branches are broken, the magic residue dashed across these rocks, it all suggests something very sinister went down. Let us sharpen our blades and brush up on our spells.

I love this detective stuff—it's right up my alley.

WHEN YOU STUMBLE UPON A CONTRAPTION AND IT TURNS OUT TO BE A DEEP LEARNING ALGORITHM

I KNOW THIS . . . I'VE SEEN IT SOMEWHERE BEFORE . . . MATHEMATICS.

I think we're supposed to say stuff to it, and then it tells us answers to stuff . . . like how to get down from the mountain.

My best friend's little brother built one of these last summer.

We cannot remove it from this dungeon. They have to operate at a precise temperature and humidity. I SAID NO, FOOL . . . DON'T TOUCH IT!

THAT PRICE TAG, THOUGH.

OK, MR. COMPUTER. WILL MY JOUSTING SQUAD WIN NEXT SEASON?

Goddess Frazaria of high intellect, give us word on how to handle a contraption like this.

. . . HOW DID IT KNOW I JUST BOUGHT A SCARF?

Drop it into the fires of Mount Zuckerfell. It is the only way.

I say we extrapolate it. Quantify it. Then make out with the cash.

I'M IN WAY OVER MY HEAD ALREADY; I CAN'T EVEN FIX MY WINDMILL.

I love how they've built this. If I was gonna build a deep learning algorithm, I would totally do it like this.

THAT'S THE OMEGA EX SIX FIVE ONE ULTRA. IT'S ABOUT FIVE TERAFLOPS FASTER THAN ITS PREDECESSOR—YOU COULD, LIKE, SUMMON THE APOCALYPSE WITH THIS THING.

I say we burn it. A technology this advanced can only cause pain and will most certainly turn the youth against us.

DOES ANYONE ELSE JUST NOT CARE?

NERDS.

How do you defeat something that is constantly changing and evolving to become more powerful? Plunge it now before it is too late.

IT'S LISTENING TO US. IT KNOWS OUR DESIRES. IT MUST BE REPORTED TO THE KING AND TO THE COUNCIL.

DON'T TOUCH IT; IT MIGHT FREEZE. JUST LET IT PLAY OUT AND DO ITS THING. YOU'LL KNOW IT'S READY WHEN IT GOES QUIET.

Let's just take this thing and get out of here.

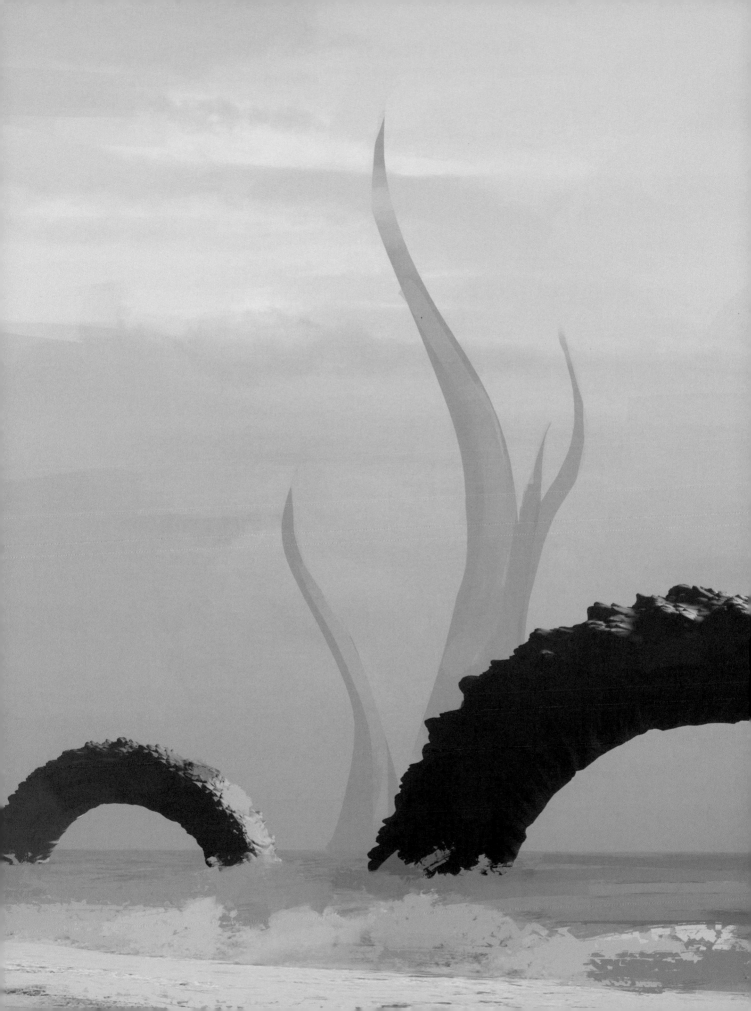

ROPES AND HOOKS, LADIES. ROPES AND HOOKS.

URGH, THE SMELL. THE STENCH OF A GIANT FISH CORPSE. A ROTTEN SEA-ZOMBIE.

THIS DRAGON DIES WITH EVERYTHING ELSE THAT HAS HAPPENED IN THIS DUNGEON.

My shield is strong, and my sword is sharp. Stand behind me if you want to live.

IT'S BEAUTIFUL. I NEVER COULD HAVE IMAGINED A CREATURE MORE MAJESTIC.

In my village, we told stories of dragons like this. They filled our nightmares. But by your side, I am not afraid.

DRAGS ALL DAY? NOT A PROBLEM, COMRADE.

APPARENTLY, IF YOU EMPTY YOUR MIND OF ANY NEGATIVE THOUGHTS, IT CAN'T SEE YOU.

HO, HO, HO, NOW I HAVE A BATTLE AX.

PULL UP YOUR SOCKS, BOYS. IT'S A BIG OL' DRAG.

Two hundred years ago, I faced off with a similar foe. That battle had haunted me my entire life. This war of mine ends tonight. HAZAARHHHH!!

DO NOT BE FOOLED BY ITS APPEARANCE. IT IS LIKE A SCARED CHILD. TIME TO SEND THIS BABY CRYIN' BACK TO ITS MAMA.

AIYEEEEEE!!!! MY COUSIN USED TO OWN A DRAGON.

DEAD OR ALIVE, THAT THING IS GOING IN MY LUNCH BOX.

I've seen this type before, a mountain-born. Horrible beasts—let's finish this quick and throw 'em on the grill.

WHEN ALL THIS IS OVER, I'M HEADING TO THE BEACH FOR SOME ICE-COLD JUICE AND A GAME OF CARDS.

YOU FIRST, FRIEND. FLIPPIN' DRAGS.

THE BODY OF A GOD, BUT THE BRAIN OF A SMALL DOG. PUPPY IS GONNA GET IT!!

THIS . . . THIS IS WHEN THE MAGIC HAPPENS.

For too many years my tribe has suffered at the hands of these beasts. With my sick magic skills, I will rewrite the books of my people. Nightmares will turn into dreams—funerals into feasts.

I READ ABOUT THIS IN A BOOK LAST YEAR. IT'S A REALLY GOOD READ. WHEN WE GET BACK TO CAMP, I'LL LEND IT TO YOU. DO YOU READ MUCH? I LOVE READING.

IS THIS A CHALLENGE, YOU SCALEY ABOMINATION? YOU THINK YOU CAN STOP MY THUNDER?! OH, HEY, PATRICIA.

38

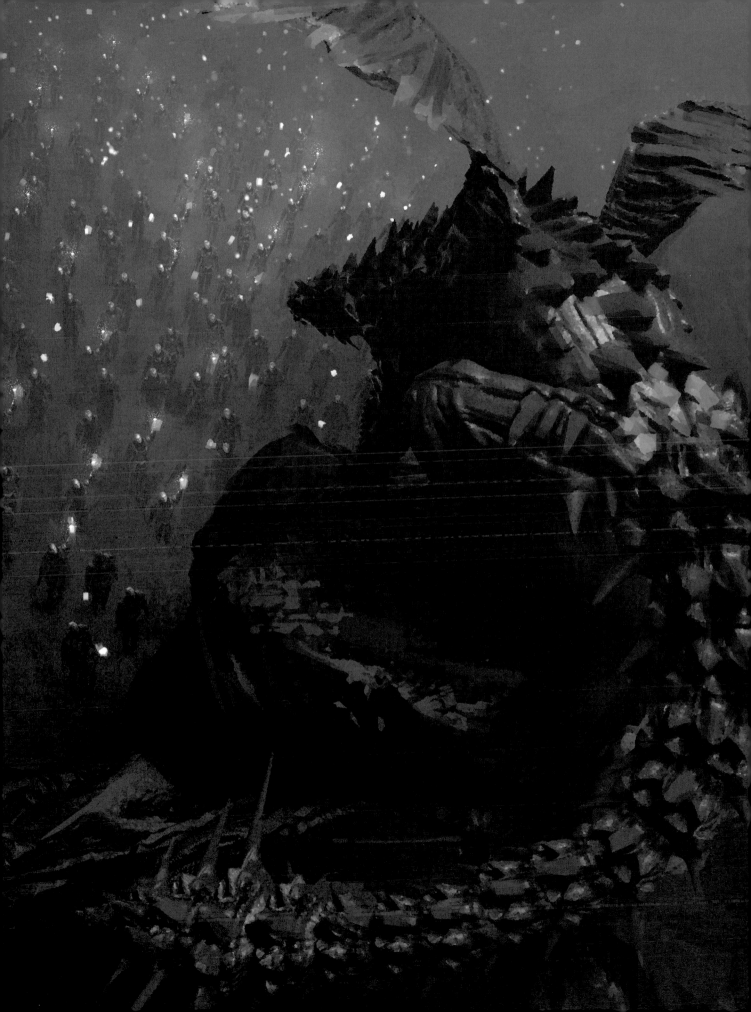

THE GLORIOUS WOLF BREED. THE ARCHETYPE OF PUREST AGGRESSION. IT IS A PLEASURE TO DANCE WITH YOU. FOLLOW MY LEAD. TRY TO AVOID MY BLADE. HAZAAARGHH.

Brush your teeth before you speak to me like that.

Are wolves the ones that keep moving when you've chopped them in half?

My aunt kept wolves as pets. I fought them into submission.

O come all ye fateful.

SPIRIT-MOTHER OF PEACE, GIVE ME GUIDANCE WITH THESE WILD CREATURES.

Don't worry, comrades; I have a spell that will easily quash any form of wolf-based attack.

Could someone just hold my ax? The hounds of love are calling.

My father kept animals like you in cages. My blade, my shield, and my fire are a far harsher fate for you and your gang.

This is far worse than that panther that attacked us in the last dungeon.

OK, boy. OK. Here, boy. Take it easy, boy.

The legend of my homeland says that wolves are reincarnations of fallen soldiers, furious at man's predisposition to pick a fight.

The question is, wolflings, do I put you to sleep, or do I make you my minions?

MY NAME IS ARKHRON MALUS ULTIMUS, OWNER OF A CAT THAT WAS CHASED UP A TREE, READER OF A TORN-UP NEWSPAPER, AND I WILL HAVE MY VENGEANCE IN THIS LIFE OR THE NEXT.

I'D TURN YOU INTO A RUG, BUT IT WOULDN'T MATCH THE CURTAINS.

I CAME HERE TO FIGHT WOLVES AND EAT FLATBREAD, AND I'M ALL OUT O' FLATBREAD.

If we injure its feet, then it can't reach us. And if we can break its jaw, it wouldn't be able to bite us. Even if it did reach us—those layers of protection, y'know?

YOU WANT TO CHALLENGE ME, BRETHREN? ARROOOOOOOO!

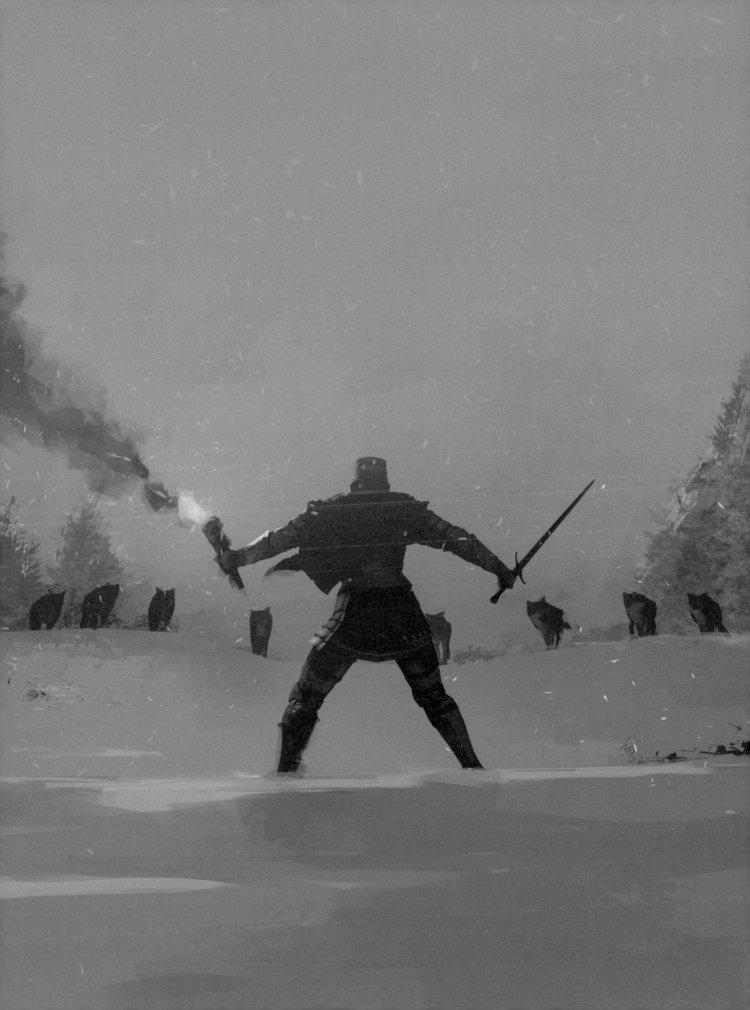

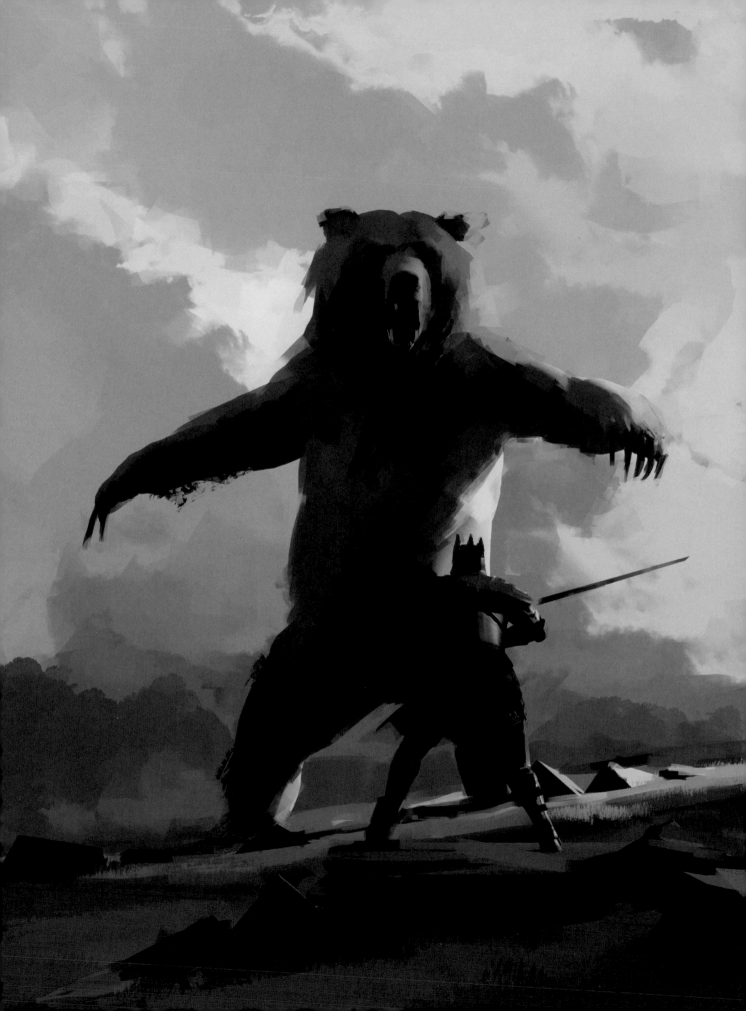

You were supposed to destroy the dragons, not join them!!

A MAJESTIC BEAST, I HAVE NO DOUBT. I WANT NOTHING MORE THAN TO HAVE YOUR SILKY HIDE GRACE THE STEEL OF MY BLADE. WITH THE COLD MOUNTAIN GRASS AT MY FEET AND UNFORGIVING MOUNTAIN AIR UPON MY SKIN, IT IS TIME TO FIGHT A BEAR.

Bahahaha . . . my father was a bear.

IT'S THE END OF THE ROAD, BEAR. WHAT A LIFE LIVED.

You're actually half the size of the last bear I killed.

I bet you were good on field days.

Are you a wizard-bear or just a regular bear?

Hairy tooth-demon, I cast you out!

The pelt is not mightier than the sword.

Look behind you, a fresh salmon—ULTIMATE PUNCH!!!!

You might be the king of this mountain, but you are not the master of my fate. Gods of Fethoratrak, I call upon thine epic strength. Scourging death-strike of Aklarios!!!

You don't have a sword, though, do you, bear?

Folks never seem to consider how bad a bear smells until they're right next to a bear, and then it's too late!

GUIDE ME, SPIRIT OF THE DARKNESS. HELP ME CONQUER THIS GNARLY GIANT.

You think you'll win this war? Because you're a bear?

I feel that it's necessary to say this: forget about your worries and your strife.

WHEN THEY TOLD ME I WAS FIGHTING A BEAR WITH A SWORD, I THOUGHT THAT MEANT THE BEAR WOULD BE HOLDING A SWORD. PERHAPS THE GODS ARE ON MY SIDE.

GIVE IT UP, BEAR. THIS ENDS NOW.

This is the finest chain mail in all of the Kingdom; I severely doubt you could defeat me with your bear hands.

Bear with me one sec while I gain insight into whether or not your fur conducts lightning.

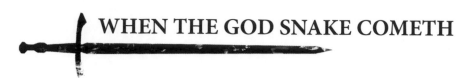

SHE'LL SQUEEZE YOU LIKE A TUBE OF TOOTHPASTE. IF THERE'S ANYTHING LEFT AT THE BOTTOM, I SHALL BURY IT IN THE SACRED FIELDS.

WRAP ME UP WITH WISDOM, AND POISON MY IGNORANCE.

That's a lot of body, guys, and a whole lotta head too.

You grotesque sausage sack! Out of our way!

Hhhsssssssssssssup dude.

We would throw snakes into the lunch boxes of our enemies in kindergarten. We were not afraid of snakes then and not now.

If we miss the teeth and dive straight into the throat, we can cut our way out.

TECHNICALLY, RICHARD, NOT ACTUALLY A SNAKE.

GLORY TO THE SERPENT QUEEN. HAVE MERCY ON OUR INFERIOR FORM.

What sacrifice can I give you, undulating overlord, that will grant us safe passage?

NO MATTER THE SCALE. NO MATTER THE SCALES.

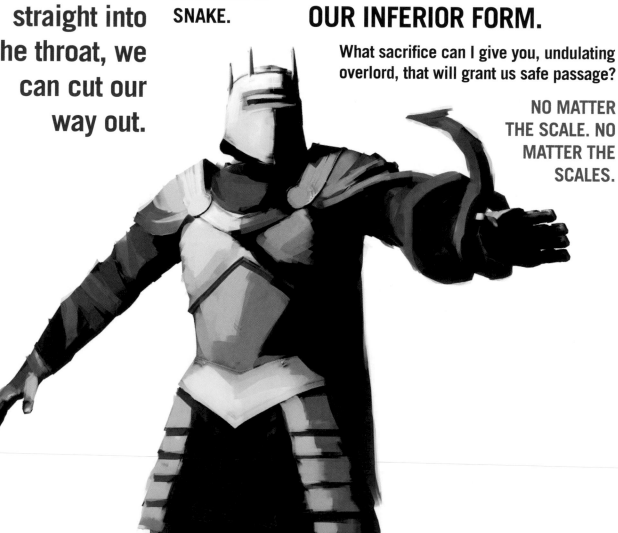

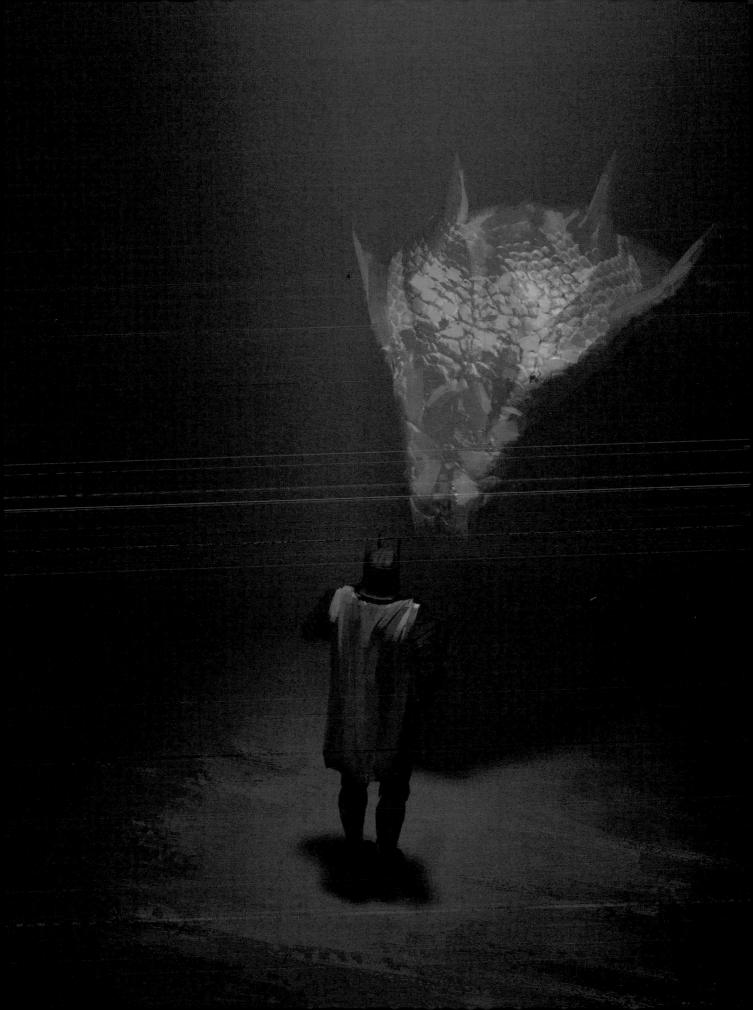

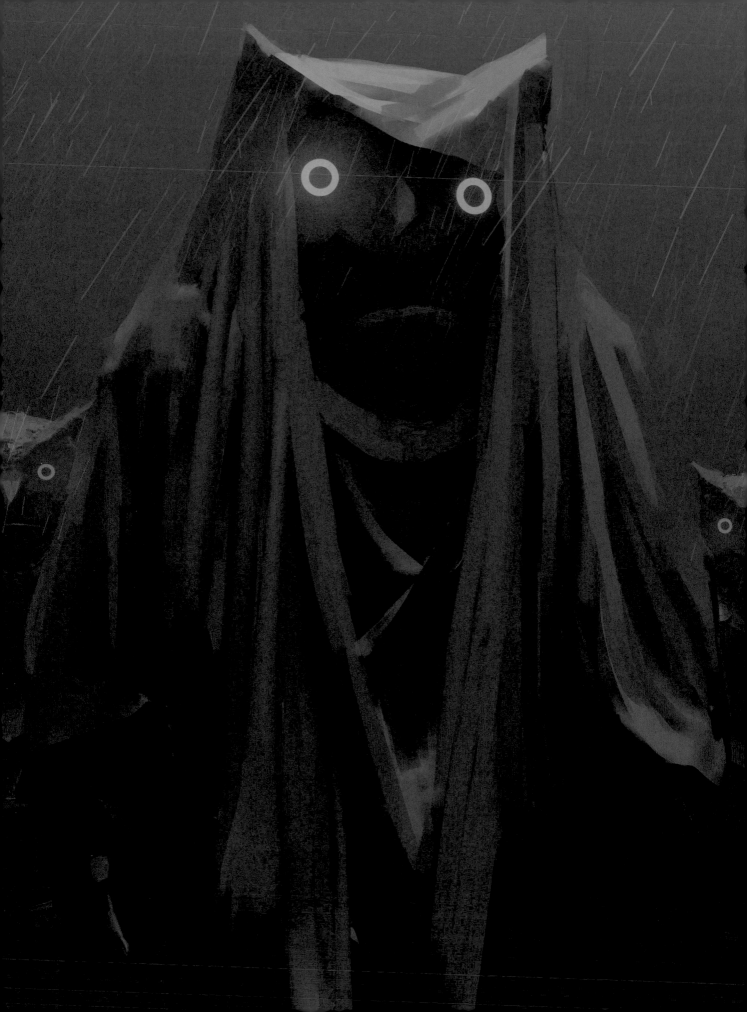

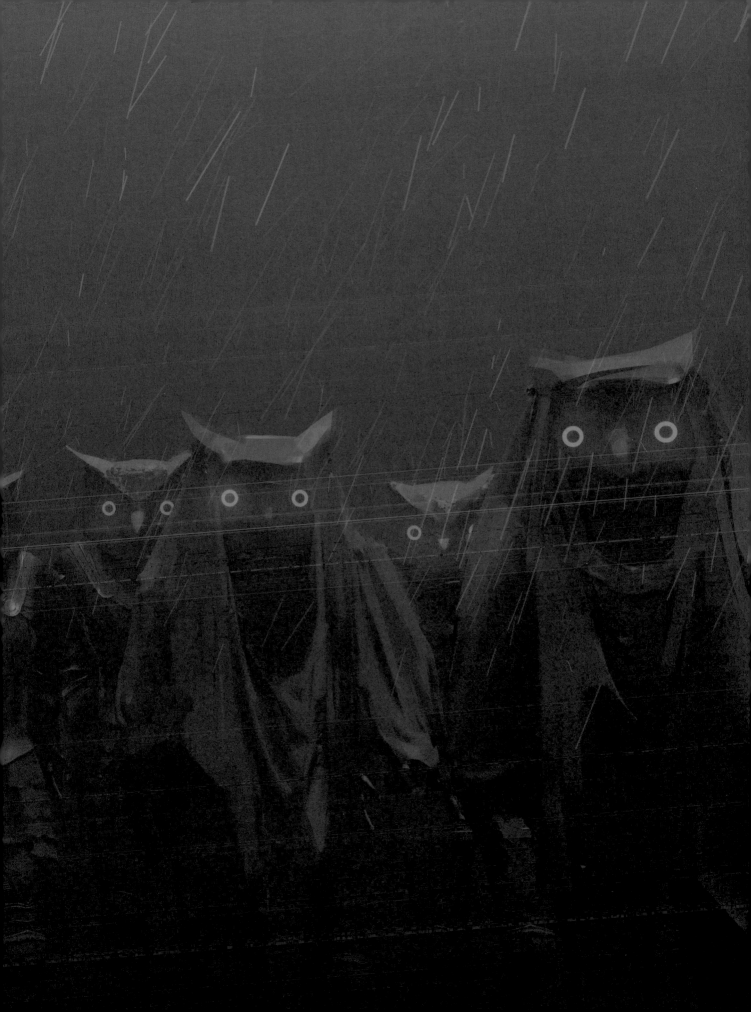

WHEN YOU'RE CONTROLLING THE RAGE THAT BURNS INSIDE YOU

Take it easy, vengeful phoenix; now is not the time to unleash the flame.

WHY DID I JOIN THIS QUEST? I KNEW THIS WOULD HAPPEN. OHHH, IT'S GONNA KICK OFF . . . WHOAAA, MAMMMAA.

I really wish you hadn't done that. I'M QUITE MAD NOW . . . *huffs and puffs*

I will not let this cloud my judgment. I will not let this ruin my adventure.

I'm absolutely fine . . . I SAID I'M ABSOLUTELY FINE. STOP ASKING ME!

See that halfling over there? . . . In about four seconds . . . I'm gonna put his head through a wall.

Why are you looking at me like that? You know what I'm talking about . . . What's with the look? You think I can't handle this? Oh, get ready, it's gonna get pretty handled right about now.

IT IS NOT A QUESTION OF HOW MUCH FIRE I CAN UNLEASH BUT OF WHEN I CAN UNLEASH IT.

I could literally BOIL A KETTLE WITH HOW ANGRY I AM ABOUT THIS!

If my dwarf friend here wasn't such a kindhearted fellow, I WOULD TEAR YOUR ENTIRE BODY IN HALF . . . ALL OF IT!!! . . . ALL OF YOUR BODY!!!!!

BAKE THOSE FIRE COOKIES, BRENDAN. CRISPY GOLDEN TOPS ON THE PAIN AND SUFFERIN' MUFFINS.

Someone cast a spell on me— something to take the edge off. I'm really losing it, here.

DOES ANYONE KNOW WHAT A VOLCANO IS?

Hours . . . turn to minutes . . . turn to seconds . . . and then I bring you the apocalypse.

The steps. Do the steps. That heavenly crystal staircase to a better time.

SOMEONE TAKE THIS ARMOR OFF OF ME!!! . . . I need to cool down, please . . . PLEASE, JUST SOMEONE COOL ME DOWN!!!!

We meet again, stoker of fires. Remind me, how do YOU like to be extinguished?

THREE, TWO, ONE . . . NOT BOTHERED.

If you notice me breathing heavily, it's because I'm filled with rage, and the only way I can stop it is to push it down deep inside of me.

Birds of peace, let me hear your mating call. Go forth and multiply the love inside my heart.

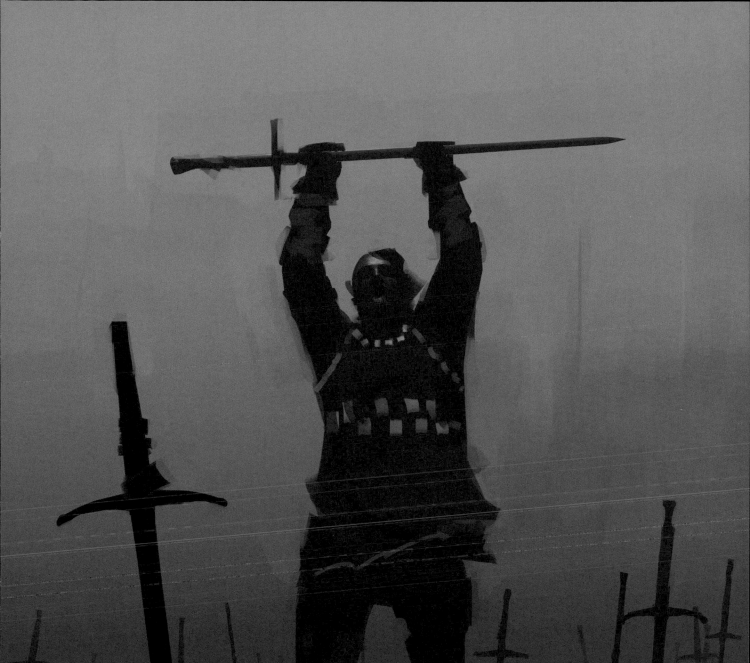

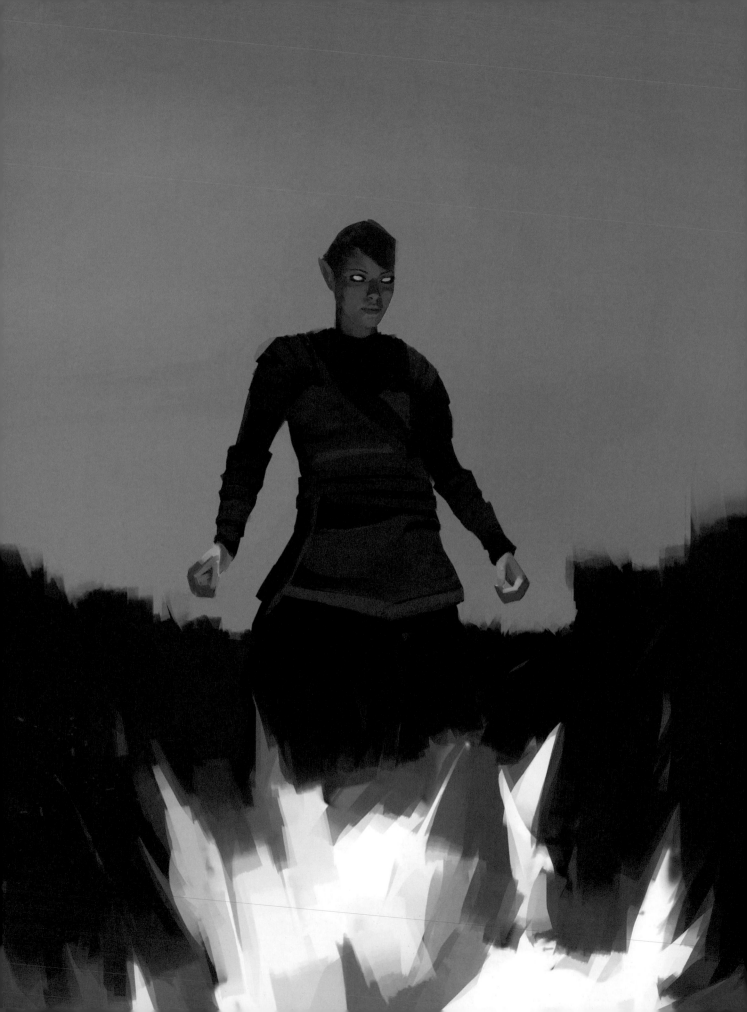

OR MAYBE WE COULD DO SOMETHING TOTALLY DIFFERENT. SO MANY OPTIONS.

You'll make us all criminals. I'm not going back to jail, Patricia, not for this.

If I knew you were gonna pull a stunt like this, I would have packed a lot more than a crossbow and a bedroll. Just take a second to think about your actions and how they impact the rest of this group.

GO FOR IT—PICK ANOTHER FIGHT, GENIUS. I'LL WRITE YOUR FAMILY A LETTER WHEN YOU DIE TELLING THEM HOW MUCH OF A GENIUS YOU ARE.

You could pull those levers and take a huge risk, or you could wait and try to figure out what this all means, as a group.

LOOK HERE, IN MY POCKET! I HAVE A LETTER, AND IT SAYS YOU'RE BEING AN IDIOT.

HANG ON ONE MINUTE, TOUGH GUY, I'M NOT SO SURE ABOUT THIS.

PLEASE . . . JUST DON'T.

HEY, LOOK OVER THERE, RICHARD—SOMETHING ELSE YOU CAN DO THAT WON'T GET US ALL KILLED.

IF WE STEAL THIS DWARF, IT WILL COST US A LOT MORE THAN FIVE HUNDRED GOLD.

There is no coming back from this should you burn this place to the ground.

What would Princess Bethiliquia think about this . . . What would she think? . . . Exactly.

Turn around and go home, or it won't just be the wolves devouring your carcass.

DO THIS, AND YOU'RE FIRED. YOU HEARD ME, FIRED!!!

Right, that's it! I'm calling the village elders, and they're coming to collect you!

PUT THAT MATCH OUT! YOU ARE INSANE!

The Great Council of Heroes warned me about this. They said I should put my hand on your shoulder and impart wisdom. Take my wisdom, brave knight. Let it guide you along a safer path.

It is as the prophecy foretold. Take your time making this decision, warrior. Be the master of our fate.

I think you've got the wrong guy. Yeah, the guy you want to pick a fight with was way back in that last dungeon.

THINK LONG TERM—COULD WE FIND A SLOWER BUT SAFER ROUTE DOWN THIS MOUNTAIN?

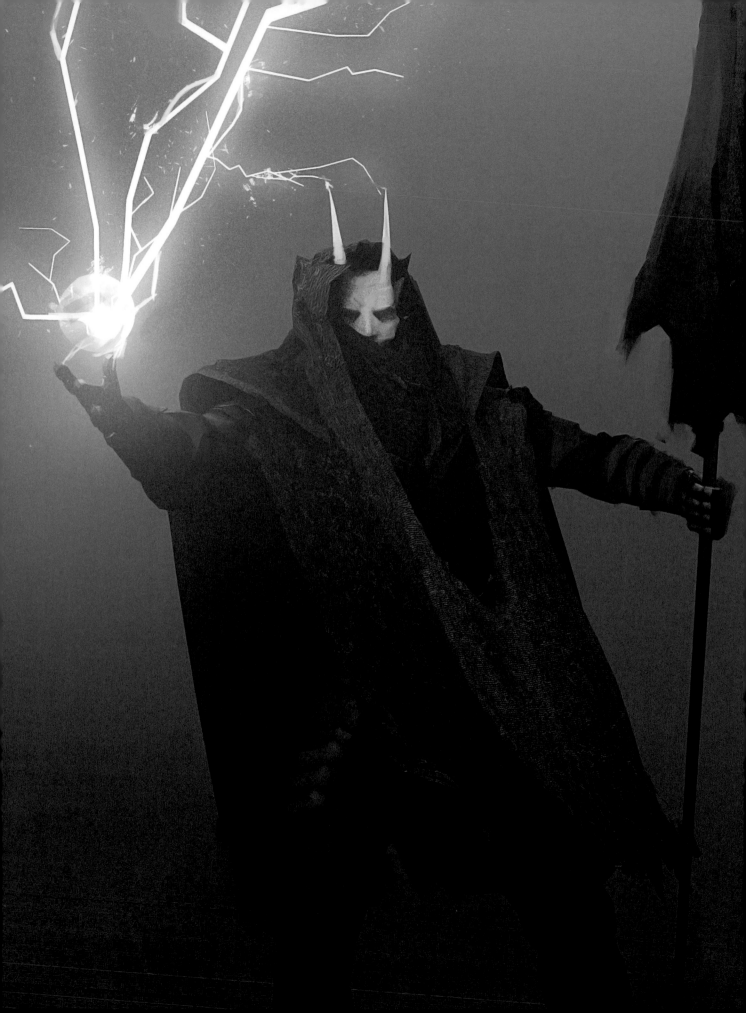

WHEN THE SQUAD IS ABOUT TO BATTLE

Dark lord of fire and sacrilegious dominion, guide my blade.

Wizard, you're in defense. Unhinged orc-halfling, I want you down the flanks. Goliath fighter, when it's time to push the button, I want you to give it all you've got, and don't look back. That's the spirit, team. HOOF, HOOF, HOOF!!

SPIRIT OF BEAR, DEVOUR. SPIRIT OF LION, PROTECT TERRITORY. SPIRIT OF EAGLE, SPREAD YOUR WINGS. BUKAAAAHHHHHHH!!!

MORE MEAT FOR MY SANDWICH. MORE FILLER FOR MY LUNCH BOX. AND THAT BEAST'S FINE HIDE INTACT, PLEASE, SOLDIERS.

Steal my cowardice, great spirit animal that roars inside of me.

On the verge of the purge.

Magic dimensions of the tesseract, bind to my staff! Hnng . . . hnnng . . . hnggyyyaaaahhhhhhh!

This beast inside I cannot contain. If I am overcome, brother, whisper the beloved poem of my childhood into my orc ears. Flowers in the summertiiiiiiiiime. Buds of blue in sprrriiiinnnnnngggg.

I can feel my blood pressure going through the roof already.

I've been reading so many scrolls about mixed martial arts. I feel like I've learned so much—like I'm there right in the middle of it as I'm reading. If I can time my strikes well and use good footwork, I reckon I'm in with a pretty solid chance.

YOU FEELIN' LUCKY, PANTHER?

FEAR IS NOT MY ENEMY, FOR IT CANNOT COMPETE. SHELTER UNDER MY WINGS, COMRADES, IF NEEDS MUST.

If I die in battle, it will be on the golden plains of Platherotraya. Not here among these desolate bottom-feeders.

TAKE OUT THE ALPHA!!

FRONT POST, BACK POST, MARK 'EM UP!

Dress rehearsal is over, squad; it's time for the opening night.

I summon the powers of my wizard forerunners. Kneel before your overlord, weakling.

FFFWASHAAAAA!

CHAAAKKAAAKKKAAAAARRRRRRNNNN!

EVERYONE IS ENTITLED TO THEIR OWN OPINIOOOOONNN!

DEATH TO THE DUNGEON SCUNGE!

DON'T OBSTRUCT THE RIGHTS OF THE INDIVIDUAAALLLLL!

DEATH-SCOURGE OF LAZARUUUSSS!

God of lightning, sendeth thine bolt of righteousness NOWWWW!

GUIDE MY BLADE, ANGEL OF STRENGTH. WATCHAAAAAA!!

JUDGETH NOT LEST YE BE JUUUUDGED!

Rage-born of dragon-heart, showeth no mercy!

I NEVER LIKED YOUUUUUUU!

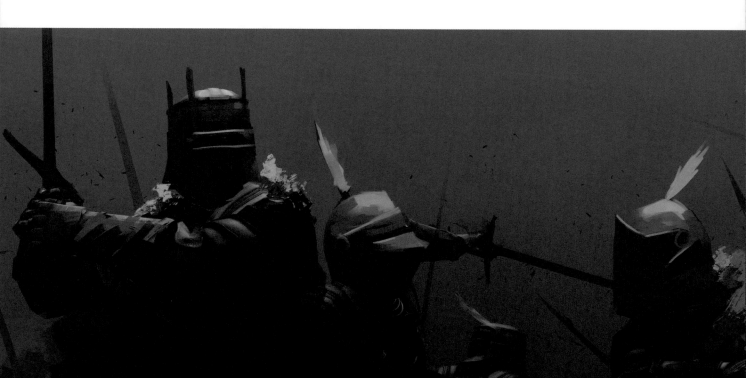

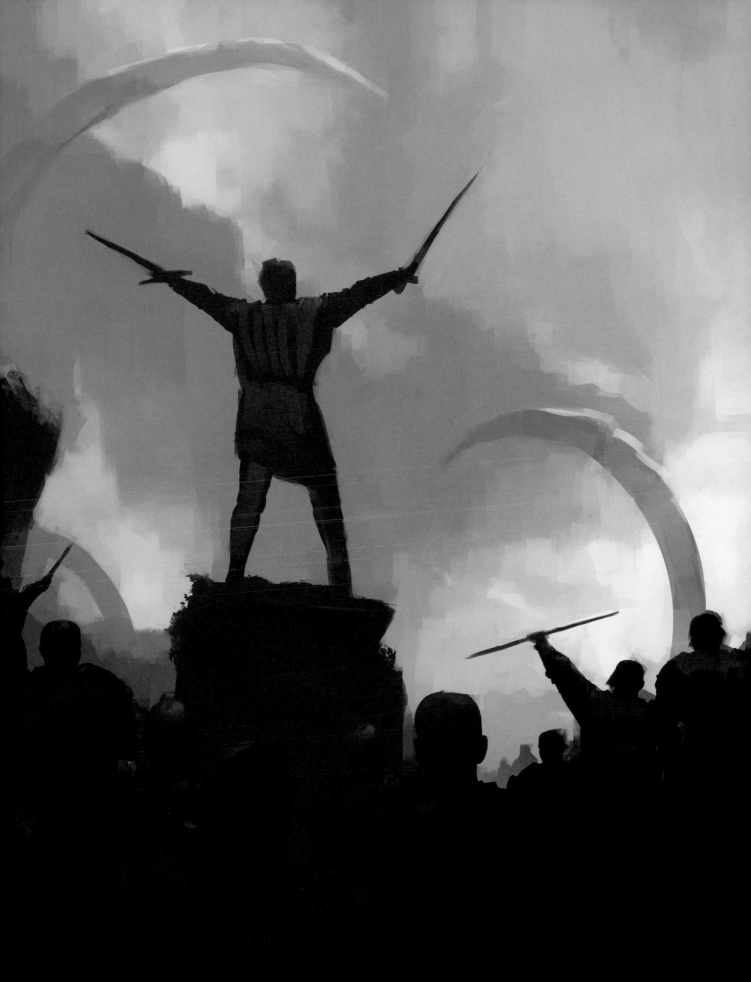

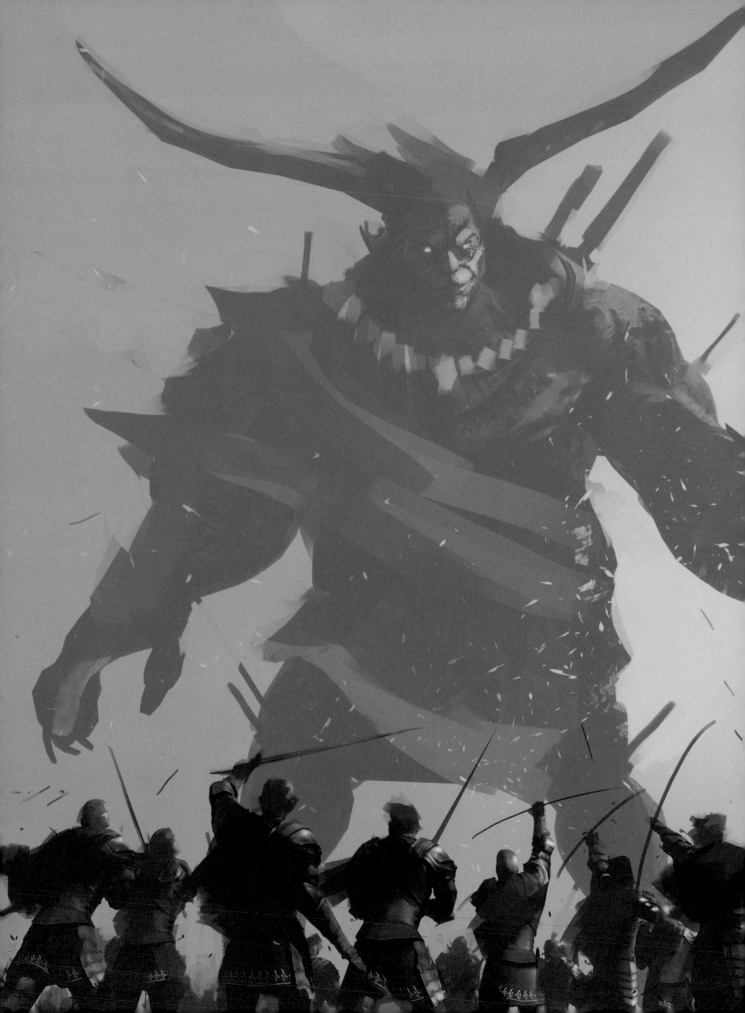

WHO SAID ANYTHING ABOUT A FIGHT? WE JUST WANNA HANG, YO!

THIS IS VERY AWKWARD FOR ME. A GIANT OF THIS SIZE DESTROYED MY COUSIN WILLIAM. MY WHOLE WILLIAM WAS TAKEN FROM ME.

I bet he has fun looking for a suitable jacket.

IF WE CAN FIND A WAY TO INCREASE THE GRAVITATIONAL PULL, IT WILL BE CRUSHED BY

Do you think he does removals?

ITS OWN WEIGHT!

I HAVE WAITED FOR THIS MOMENT MY ENTIRE LIFE. TWO HUNDRED YEARS TO FIND A FOE WORTHY OF MY FINEST LUNGE.

I'm gonna sneak around the back; it's my best chance.

We had a guy like that on our jousting squad. Beast was our meal ticket for four seasons.

I'M A BIT OF A BEAST-BENCHER. TRUST ME . . . NOT AN ISSUE.

THAT GUY'S MASSIVE!

My aunt professed that I would meet my end against an opponent more than twice my size. She always hated me. She once gave me a Christmas card that said, "Leave the family; I don't want you here."

I SURE HOPE THAT'S JUST FORCED PERSPECTIVE.

THE WINTERS ARE NOT LONG ENOUGH TO COOL HIM DOWN. WHEN THE SUN SETS, HE CAN SEE OVER THE HORIZON.

I've been doing my squats, team; there is nothing to fear.

Can someone just rub my eyes for me? Go on, give 'em a good ol' rub. YIKES.

Nigel . . . you did remember to bring the extralong spears?

Orc halfling, jump on my shoulders. We'll show 'em what a real giant looks like.

MY GRANDMOTHER TOLD ME A STORY ABOUT A SMALL KNIGHT THAT DEFEATED A GOLIATH TEN TIMES HIS SIZE. NOTHING MORE THAN A TOTAL FANTASY.

Its mouth is like a horse's ass! Grab some of that mint plant ASAP!

Peter, I have a longer, more accurate weapon in my satchel; would you mind passing it to me?

WHO'S BEEN TAMPERING WITH MY SWORD?!

You wish to embarrass me, Gods?!

MERCIFUL PRIESTESS OF THE NINE KINGDOMS, PLEASE RESTORE MY COORDINATION TO ITS ORIGINAL FORM.

When we sit around the campfire, we will merely laugh at these moments. Hahahaha . . . I can imagine us there right now.

How very fortunate for you.

COME BACK HERE!

I'M JUST DANCING AROUND YOU RIGHT NOW—MY NEXT ATTACK IS THE ONE THAT HURTS.

THINK YOU CAN JUST DIP AND DODGE YOUR WAY THROUGH LIFE, HUH?

YOU BETTER WISH I STOP SWINGING!

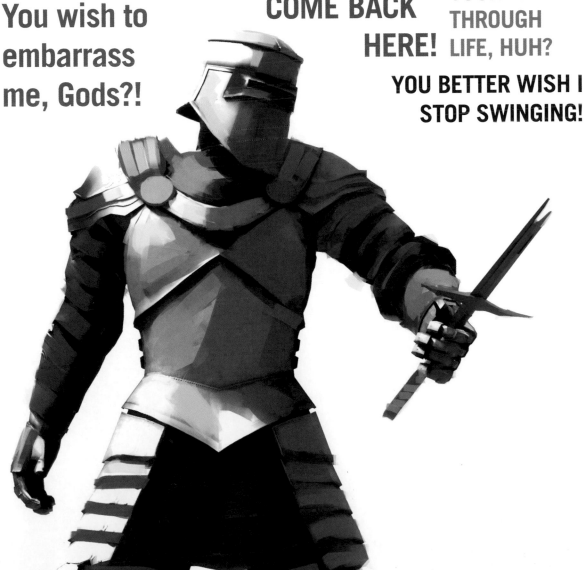

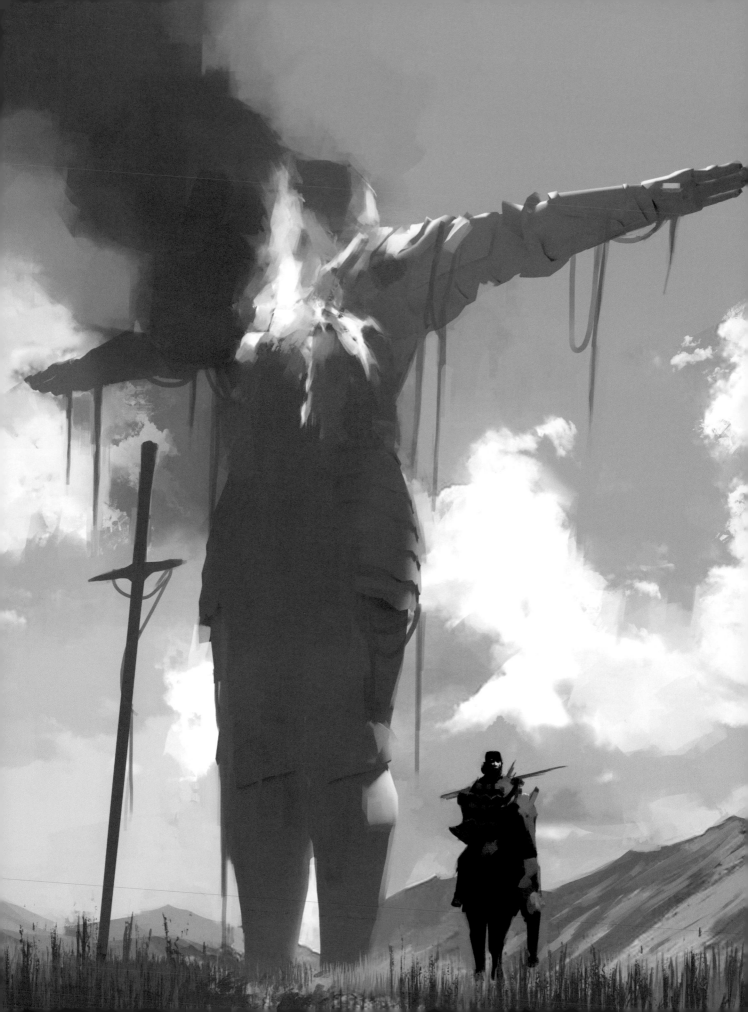

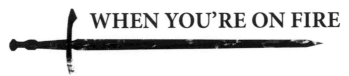

IS THIS MY FATE?! TO BE STOLEN FROM THIS WORLD BY THE SAME FLAMES THAT TOOK MY FATHER? BLARRRHH!

Don't look at me!
Don't look at me!

RAAAAARRGHHH! BLAARRGGHHH! HNNNYRRAAHHH, SAVE THE CHILDREN!

Kinda wish I hadn't thrown that bottle of water away now.

Give it a few minutes; if it doesn't die down, I'll use one of my spells.

Hahaha, you think this fire will penetrate my armor? Gilded by the Seykhran orcs with the finest magic leaf, it merely feels like standing in the sunshine on a warm spring afternoon.

Ahhh, let the heat embrace you. Breathe in the purest flame. I am the god of fire.

CAN ANYONE ELSE SMELL BURNING?

ARE YOU JUST GONNA STAND THERE AND WATCH ME BURN?

Gather your strength, soldier of the night, and rise like a phoenix.

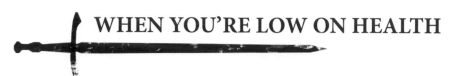

WHEN YOU'RE LOW ON HEALTH

I WORRY THAT AS I PASS INTO THE NEXT LIFE, MY WORDS WILL NOT MAKE SENSE . . .

I'M FINE.

Battle is my lifeblood. My sword is my wine. My shield is my bread.

THIS REMINDS ME OF THAT TERRIBLE SONG ABOUT BLEEDING.

SHUBBALUBBAWABBLUB.

Do not do what I will not not do . . . HRPPHHH!

Go. Just go without me. You can make it. I'll be fine here. No, please. Listen to me. You have to go.

ARGH, IT BURNS! IT BURNS LIKE THE FIRE OF MOUNT PRAKTORIA!

I'm starting to feel a little woozy, guys.

Throw me some points, Big Mac. Give me some of that secret sauce . . . urghhh.

If I leave this world, the golden shores of Aklarios will welcome my soul. Hnggg . . . tell me your secrets, Aklarios.

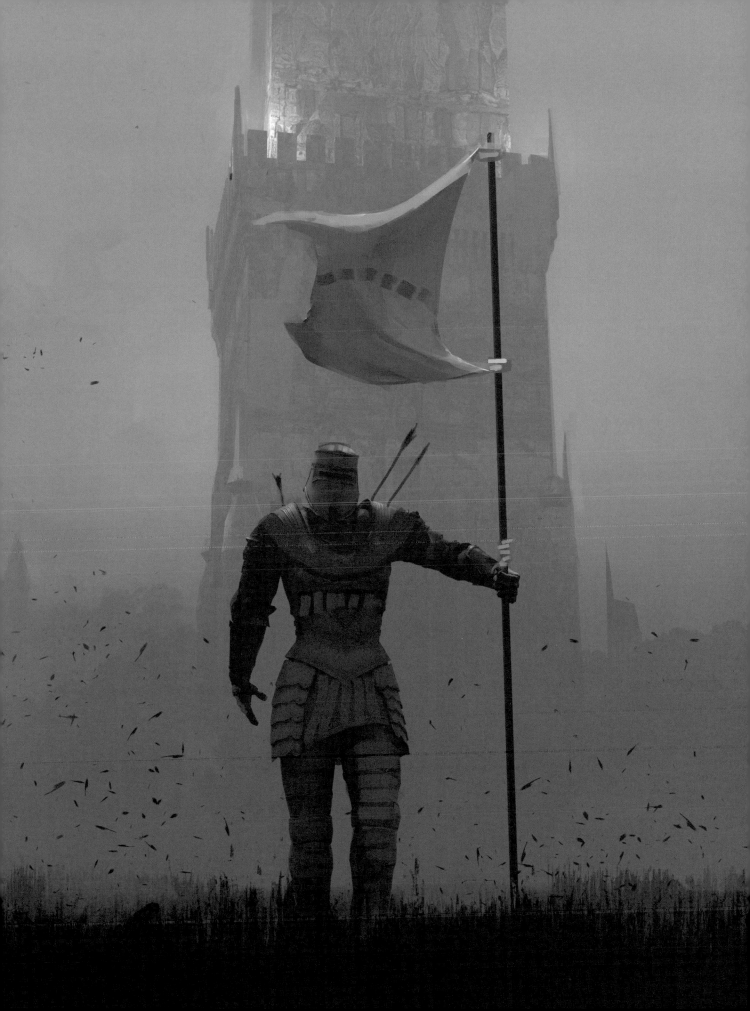

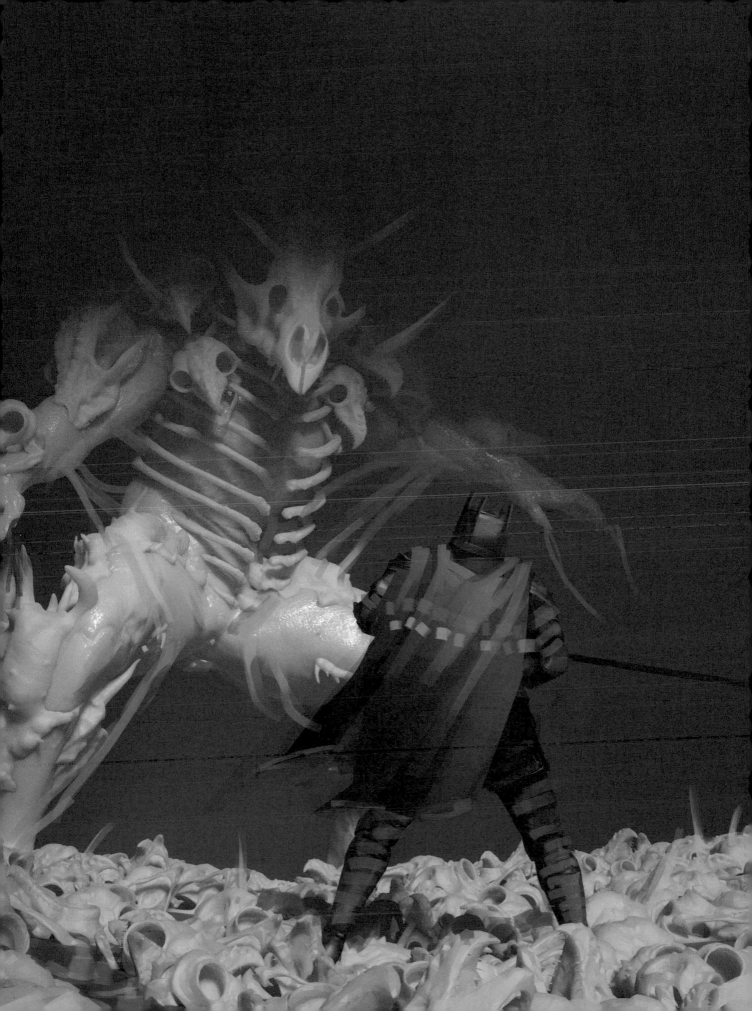

OOH, TAKE MY BOTTLE. SOMEONE TAKE MY BOTTLE. I DON'T WANT IT TO TOUCH THE RIM.

Being covered in sticky gloop and goo is actually one of my favorite pastimes.

Don't let it touch your lips or nostrils.

I THINK I'M GONNA THROW UP.

Fortunately, I have many jars. Try to scoop as much in as you can; it is essential for my research.

TAKE ME BACK TO THAT RABID GIANT BEAR ANY DAY. THIS IS HORRIBLE.

A WHOLE NEW CATEGORY OF EVIL.

YUMMY.

Look, you can blow bubbles with it.

DID ANYONE PACK A CLEAN RAG?

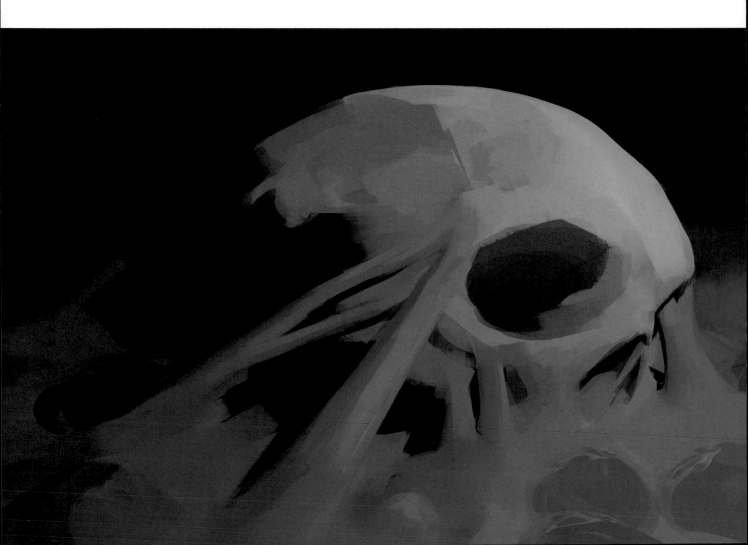

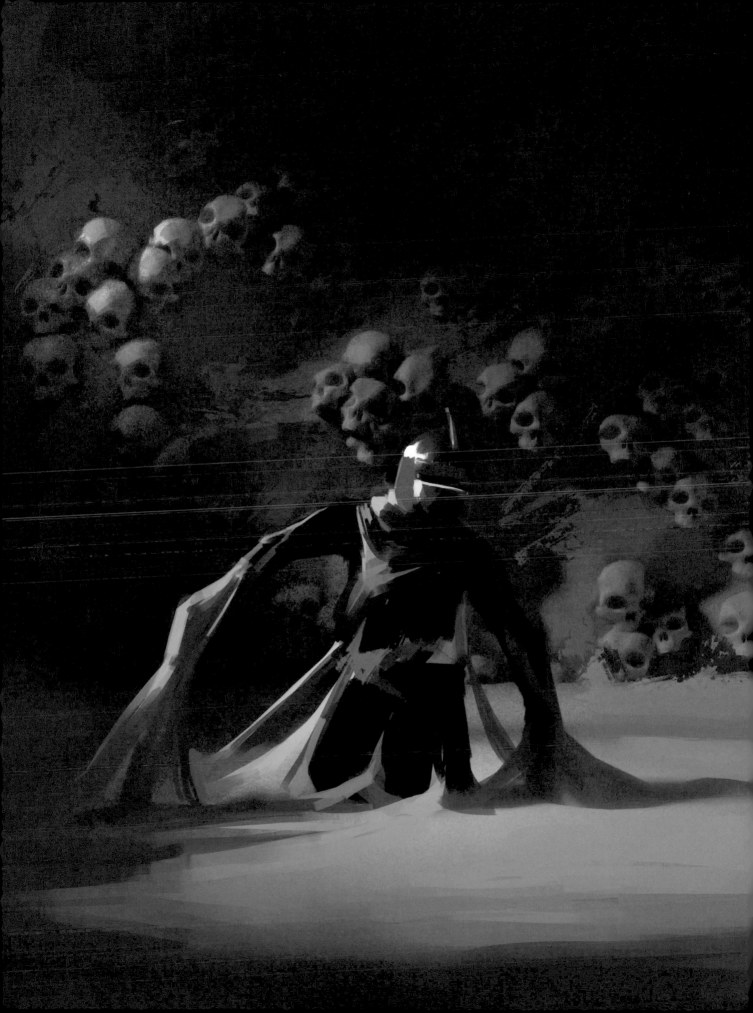

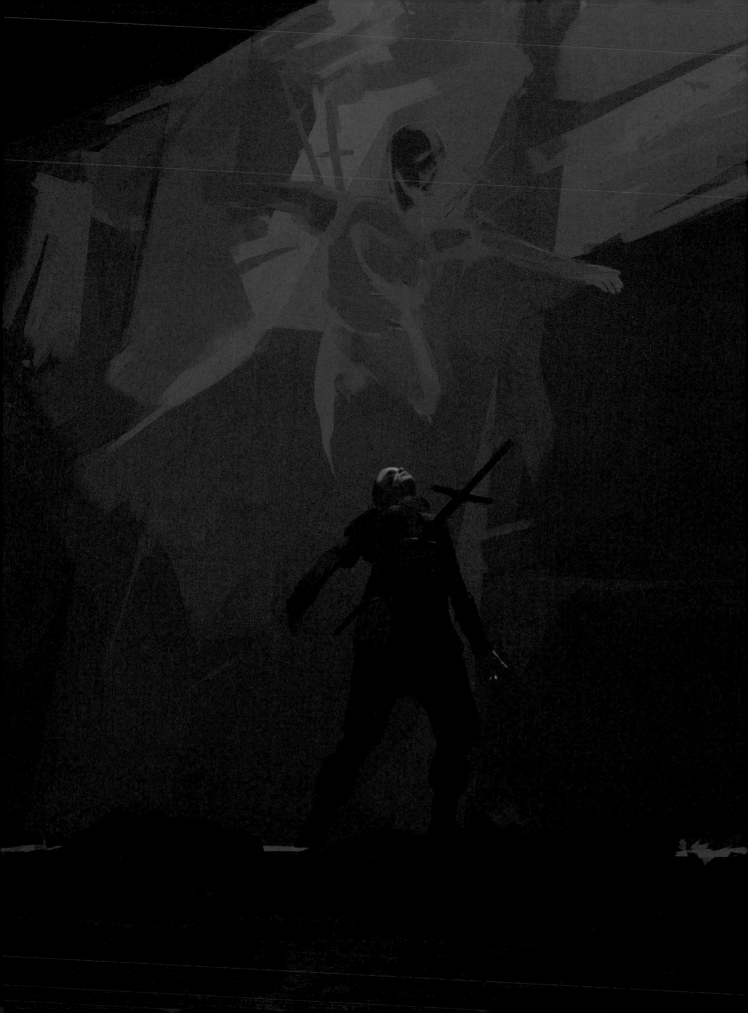

WHEN THE SOULS OF THE DEAD RISE UP AND ATTACK YOUR COMRADES

Stand behind me. I will GUARD YOUR HEART.

Easy. I'll just use my trusty SOUL ARROW . . . here it COMMMMEEEESSSS!!!

Lol . . . that awkward moment when you realize your enemies can't be killed.

IS THAT ONE OF THE GUYS I KILLED?! WOW, THAT'S A WHOLE NEW LEVEL OF AWKWARD.

How do you kill something that is already dead? *Snivels and then shouts* HOW? . . . HOW DO WE END THIS?!!!

WHAT A WAY TO RING IN THE NEW YEAR . . . WASN'T 220 JUST SO F&%$ING FANTASTIC?

IF ANY OF YOU GUYS GO DOWN, DON'T DO THIS, DON'T COME BACK—IT'S NOT RIGHT. *SNIFFLE* IT'S NOT RIGHT.

Someone needs to kick back and chill touch.

BACK DOWNSTAIRS, DEMON. BACK DOWN INTO THE DARKNESS.

WHAT EVIL IS THIS BEFORE US? SURELY, THE STORIES WERE NOT TRUE. SISTERS OF NMABIA, SAVE ME FROM THIS NIGHTMARE.

HOW MANY TIMES YOU GOTTA KILL THESE GUYS?!

THERE'S SOMETHING STRANGE IN THIS NEIGHBORHOOD. I FEEL I SHOULD CALL SOMEONE, BUT I DON'T KNOW WHO! WHO AM I GOING TO CALL?!

If we mix vinegar with orc blood, it forms an acidic cloud that destroys ghosts. Look it up if you don't believe me.

I SAY WE JUST SLIP OUT THE SIDE. JUST SLIDE ON OVER TO THE EXIT. SHHH, GUYS, C'MON. SLIPPY SLIDEY.

As my courage binds with my armor and my righteousness, my blade, I cast the souls back to the depths of this dungeon. Deeper. Forever darker. For eternity.

I DON'T THINK WE NEED TO FIGHT THEM. I THINK WE NEED TO STUDY AND LEARN FROM THEM, EDUCATE OURSELVES ABOUT WHY THEY MIGHT WANT TO PULL US DOWN INTO THE DARKNESS.

RIPPING CLOUDS. BREATHING SOULS.

Ahh . . . that's how Uncle Peter was able to visit on Christmas . . . so it WAS him.

OUR FELLOW DUNGEONEER IS NO LONGER WITH US. MY BLADE IS ONE OF MERCY. LIGHTNING-DEATH-STRIKE OF AKRAYSHIA!!!!

OH, CHRIS! OH, CHRIS . . . NO!!!

Let's not make any rash decisions. I say we travel to the next town. Collect all our gold and crystals, and pay a professional to sort this out. Or at least exhaust all our options, and then kill it with fire.

HAHAHA, GREAT JOKE. OH, LOOK AT ME. I'M POSSESSED. SERIOUSLY . . . REEL IT IN. NO ONE'S BUYING IT.

ETERNAL FLAME OF RIGHTEOUSNESS, RESCUE MY ALLY FROM THIS SUFFERING.

There is one thing I could try, but I don't think it's legal anymore.

I can handle the dragons and the sadistic elves, but not this. NOT THIS.

I guess we should avoid her for a while—give her some time to chill out.

Get your sick demon ass OUT OF MY FRIEND! WAHYAAAAAAA!

THE SAME THING HAPPENED TO MY MOTHER. WE'VE BEEN RUNNING FROM THAT DEMON OUR WHOLE LIVES. SHE CAUGHT UP WITH ME ONE NIGHT IN THE WINTER AND KISSED ME ON THE FOREHEAD JUST AS I WAS FALLING ASLEEP—WITHOUT A DOUBT THE MOST TERRIFYING THING THAT HAS EVER HAPPENED TO ME.

WHY DID HER VOICE SUDDENLY CHANGE? YOU OK, PATRICIA?

My elders warned me—there is always something darker than the absence of light.

DEEP BREATHS, RICHARD, NICE AND SLOW.

There is no cure for this darkness. No light for this sickness.

I only carry the holiest water. Take a drink, my troubled friend. Let the healing trickle through your body. Ice . . . cold . . . holy.

ON THE MOUNTAINTOPS OF SEPRECIA'S KINGDOM IS AN OLD CHAPEL. WE MUST PUT HIM TO SLEEP AND TAKE HIM THERE. IT WILL TAKE US TEN YEARS, BUT IT IS OUR ONLY OPTION.

LOOKS LIKE SOMEONE ELSE HAS JOINED OUR QUEST. WHERE DO YOU SEE YOURSELF IN FIVE YEARS, DEMON?

NOTHING A GLASS OF CRISP APPLE JUICE COULDN'T REMEDY. HOW ABOUT IT, MY OLD FRIEND? CHUNKY OR SMOOTH?

I know you're in there, sweet guardian of my heart. Return to me, your love, your comrade, keeper of this sacred bond. Mmmyuh . . . mmmyuhhhhhhhhhh.

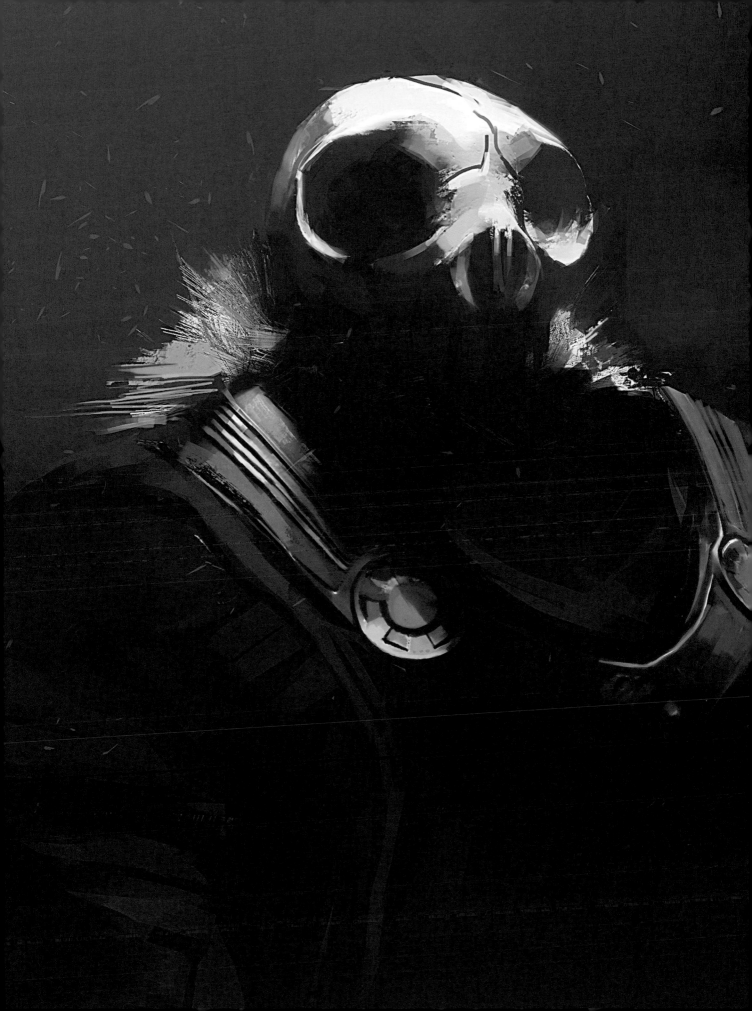

SIGH . . . ANOTHER SOLO MISH DOWN IN THE DUNGEON.

IF WE'RE BEING HONEST WITH OURSELVES, WE'RE THE CORE OF THE GROUP ANYWAY.

I sense an absence within the ether. *Draws a long breath* We are alone but not lost.

HELLOOOO . . . HELLOOOO . . . STRENGTH IN NUMBERS??!!

If you're gonna nominate me leader, how about you consult me before you WANDER OFF INTO THE DARKNESS? OH WELL.

AT LEAST WHEN SHE GETS RIPPED IN HALF BY A GIANT SPIDER, WE WON'T HAVE TO BE THERE TO SEE IT OR DO A LITTLE DANCE ABOUT WHETHER OR NOT TO INTERVENE.

OH, I'LL JUST USE MY MAGICAL DEVICE TO CONTACT THEM FROM A DISTANCE. RING RING RING, HELLO, MISTER MAGICAL DEVICE OPERATOR; CAN YOU NOTIFY MY FRIEND, PLEASE.

They drew a little stick figure on our map; that must be where they went.

When they return, one of you guys is gonna have a word.

MORE LUNCH FOR ME!

GUYS, LET'S NOT SAY ANYTHING INAPPROPRIATE ABOUT OUR FRIEND. ONE MINUTE YOU THINK THEY'VE LEFT THE GROUP AND THEN YOU REALIZE THEY'VE TRANSFORMED INTO AN INVISIBLE CLOUD, TOTALLY LISTENING TO ALL THE THINGS YOU SAY.

I wonder where our friend went. Probably off somewhere being an ABSOLUTE LEGEND.

ONE . . . TWO . . . THR—HANG ON, GUYS—WHERE DID OUR FELLOW DUNGEONEER GO? I KNOW NO ONE SAID WE WERE GONNA STICK TOGETHER; I JUST ASSUMED WE WOULD, GIVEN THE CURRENT LIFE-THREATENING CIRCUMSTANCES.

Did someone give them a different map? I thought all our maps were the same?

ON MY LAST ADVENTURE, I WENT LOOKING FOR MY ORC FRIEND MARPRIBILLO, AND IT WAS SUCH A MISTAKE—HIGHLY EMBARRASSING FOR BOTH PARTIES WHEN I WALKED IN.

BUT I'M STILL CARRYING THAT OLD BOOK SHE LENT ME . . . IT'S A PRETTY HEAVY BOOK, GUYS.

OH NO, DID WE FORGET THEIR BIRTHDAY? OH JEEZ, THAT'S SO AWKWARD. GO FIND 'EM AND I'LL WRAP UP THIS HAM.

I'll go into a dungeon with a group of mercenaries, I'll go into a dungeon with a team of athletes, but I wouldn't go into a dungeon all by myself . . . WE HAD A DEAL!

I say we all start screaming for help to see if he comes back. You see, there was this boy in my village who cried wolf every night; now he's one of the world's most widely respected hunters—what a great guy.

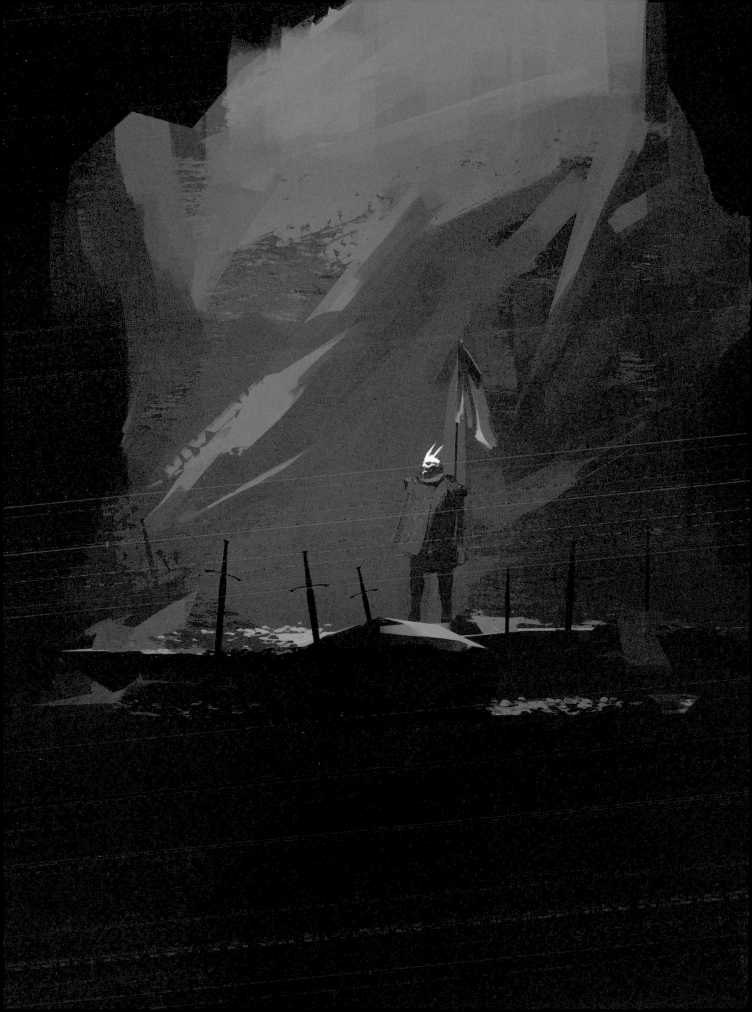

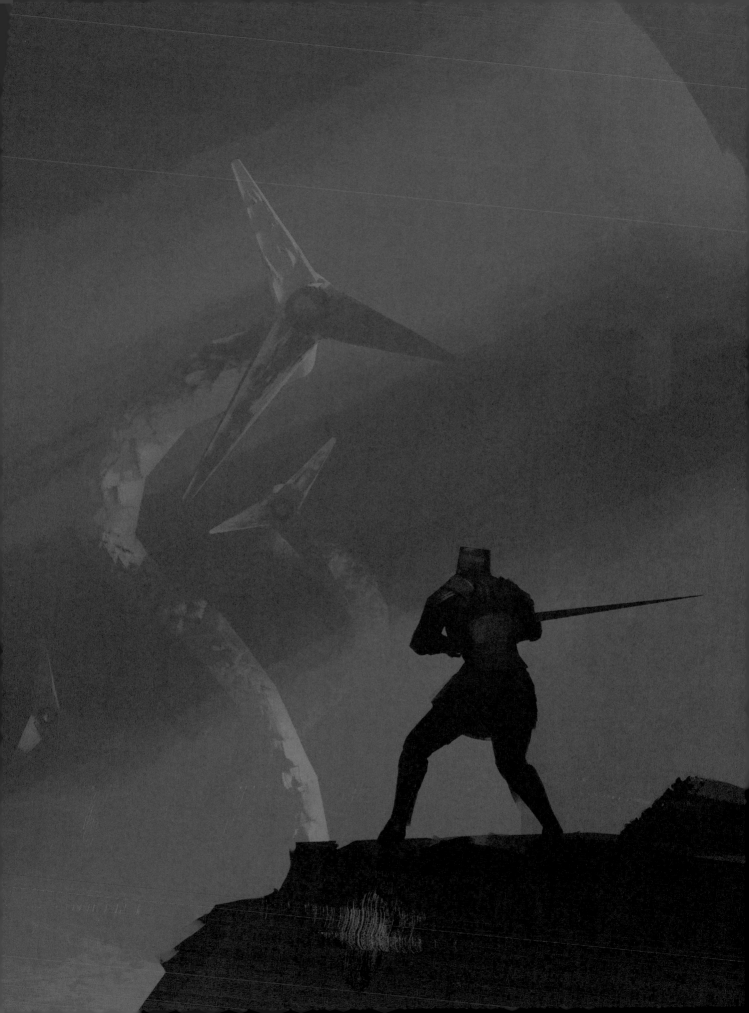

THIS IS SUCH A HEADACHE. WE DON'T EVEN KNOW IF WIZARD'S RIGHT ABOUT THIS. WHERE'S MY ENERGY VIAL? URRRGGGHHHHHHH.

The prophecy of the Mountain Oracle Alaynia very clearly stated that should we proceed; things would only get worse. Let's go back to that bar, grab ourselves a fine ale, and reminisce about this crazy unfinished journey.

Oh, I just remembered—there was another quest I was supposed to join. Sorry, guys, I'm gonna have to call it a day. Have a FANTASTIC TIME.

PLEASE, CAN WE GO BACK NOW?

THERE'S NO PLACE LIKE HOMIE'S SICK VIKING CASTLE. THERE'S NO PLACE LIKE HOMIE'S SICK VIKING CASTLE.

OH, LOOK, ANOTHER REASON TO GO HOME.

I have always sought the path of glory and righteousness. But as I search deep inside myself, deep, deep, down inside, I really don't give a sh$&.

With the gods as my jury, I choose to lay down my weapons and return to my homeland. I would rather live a coward than die a champion.

I COULD REALLY GO FOR ONE OF THE RANDOM HORSE AND CART TRAVELERS CASUALLY PASSING BY OFFERING US A RIDE RIGHT NOW.

Here, take my sword. If you want to be a big tough guy, go for it. I'm heading back to where my head doesn't get ripped off. *Shouts aggressively* TOODLES!!

Holy spirit of greatest wisdom, is this where my journey shall end? Help me convince my comrades that it is time.

I'm tired, guys. Tired of being a hero all the time. I just want to be a normal person—a regular King Joe . . . KJ on the regular. IT WAS A MISTAKE.

I NEVER THOUGHT I'D HEAR MYSELF SAY THIS—I MISS PLOWING THE FIELD. THERE YOU GO. IT'S OUT THERE.

I THOUGHT I COULD DO IT. I THOUGHT I COULD BE A HERO. NOT FOR ME. BYE.

MY UNCLE WOULD PUNISH ME FOR BEING A QUITTER. HE SAID I ALWAYS GAVE UP UNDER PRESSURE. WELL, I SURE GAVE UP YOUR LOCATION WHEN THE KING'S GUARDS CAME LOOKING FOR YOU, DIDN'T I UNCLE . . . DIDN'T I . . . MORH HAHAHA.

Thine bed or thine grave. Thine return or thine dungeon. Don't let thine ego force thine hand.

WHO WOULD HAVE KNOWN? DUNGEONEERING IS NOT FOR ME. IT'S JUST NOT MY FIELD.

Do you know what I don't have at home? Wave after wave of monsters and criminals trying to kill me.

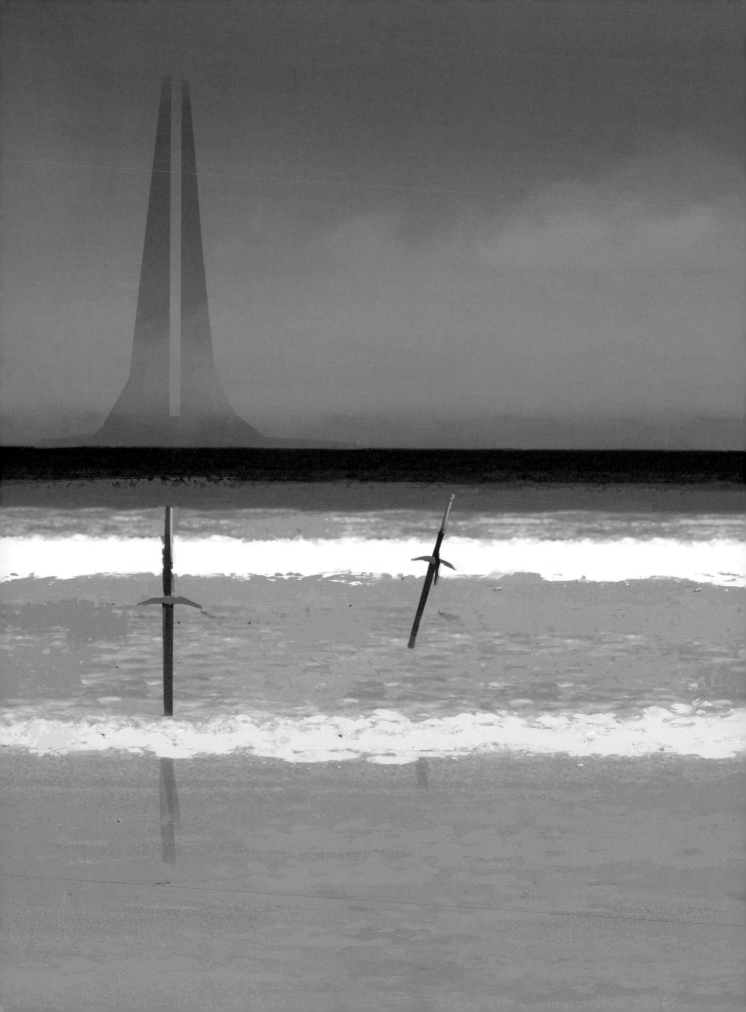

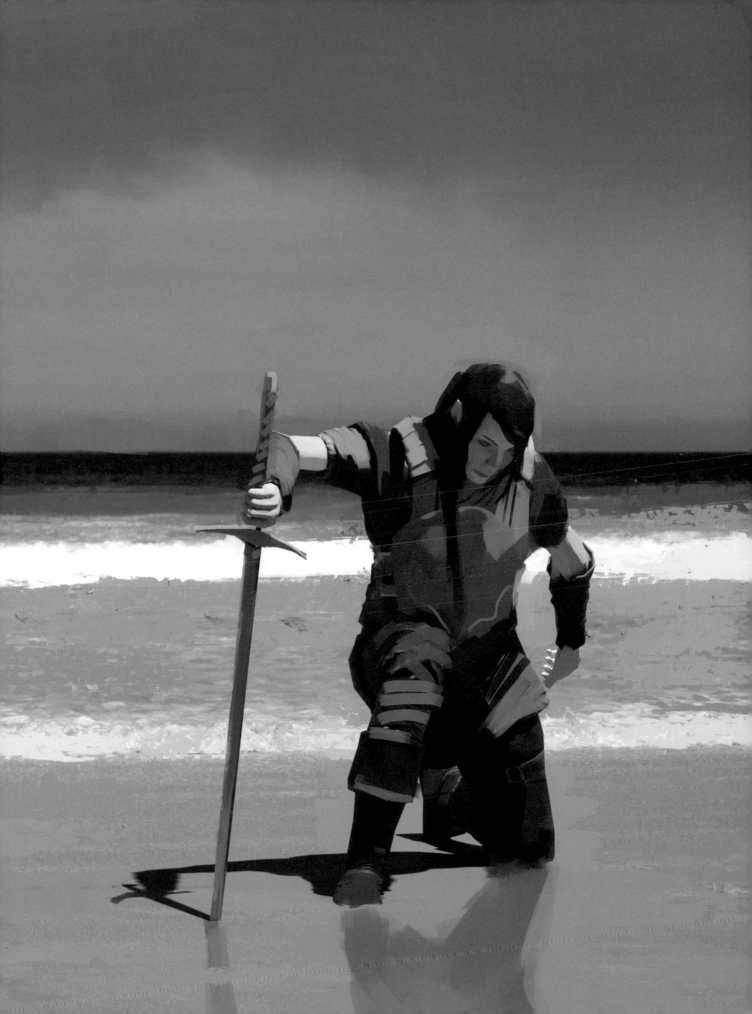

Feeling awfully secure in this.

I do not wear this because I am weak; I wear this because I am wise. Kneel at my side, and give thanks to your newly armored comrade.

A BODYSUIT FIT FOR THE GODS!

I think this once belonged to King Framaniton the Fifth. See . . . it has his name on it right here. See? Just by the collar . . . I think that's what it says . . . yeah, King F V— that's him . . . that's Framaniton.

IF I CAN GET 'EM IN A HEADLOCK, IT WOULD BE LIKE A GIANT PRINTING PRESS. LET OUT SOME STEAM AND JUST CRUSH IT.

I WOULD HAVE PREFERRED IT IN WHITE, BUT THIS WILL DO FINE. WATCH OUT, DARKNESS, HERE COMES YOUR NEW MASTER. HNNNG . . . HNNNGGGGG . . . HYAAAAAAHHHHHH!

I FEEL LIKE I'M THE NEW POSTER BOY FOR TOTAL DESTRUCTION!!

Whoa, this thing's decent! Yo, get a load of this! You want one too, right? Yeh, I bet!

All jokes aside, I do feel incredibly jacked up with this on. GET OUT OF MY CASTLE! *Laughs out loud* Yeah, I could see it going that way, easily.

Deep in the heart of darkness, a brave group of warriors continue on their quest. One of the warriors, the chosen one, has recently acquired an insane defense upgrade.

BEAST MODE.

I can just about get this past my big muscles. Come on baby, in ya go.

I SHALL CARRY THIS ALONG OUR PATH FOR MANY MILES, USE IT AGAINST MANY FOES, AND THEN DISCARD IT WHEN I FIND SOMETHING BETTER. BUT NOT YET, ARMOR . . . NOT YET.

THE COLD METAL ON MY SKIN. ENTWINE WITH ME, ARMOR OF LIGHT.

STILL GONNA AVOID THOSE DRAGS—DON'T WANNA GET COCKY.

NO ARROW CAN BREACH, NO AX CAN CRUSH, AND NO SPELL CAN SHAKE THIS FINE NEW SHIELD.

Be honest with me—if you saw this coming toward you, would you just pack up your stuff and go? Terrifying. Absolutely terrifying.

If only I had something like you last summer when the rabid zombie elves tore through our village.

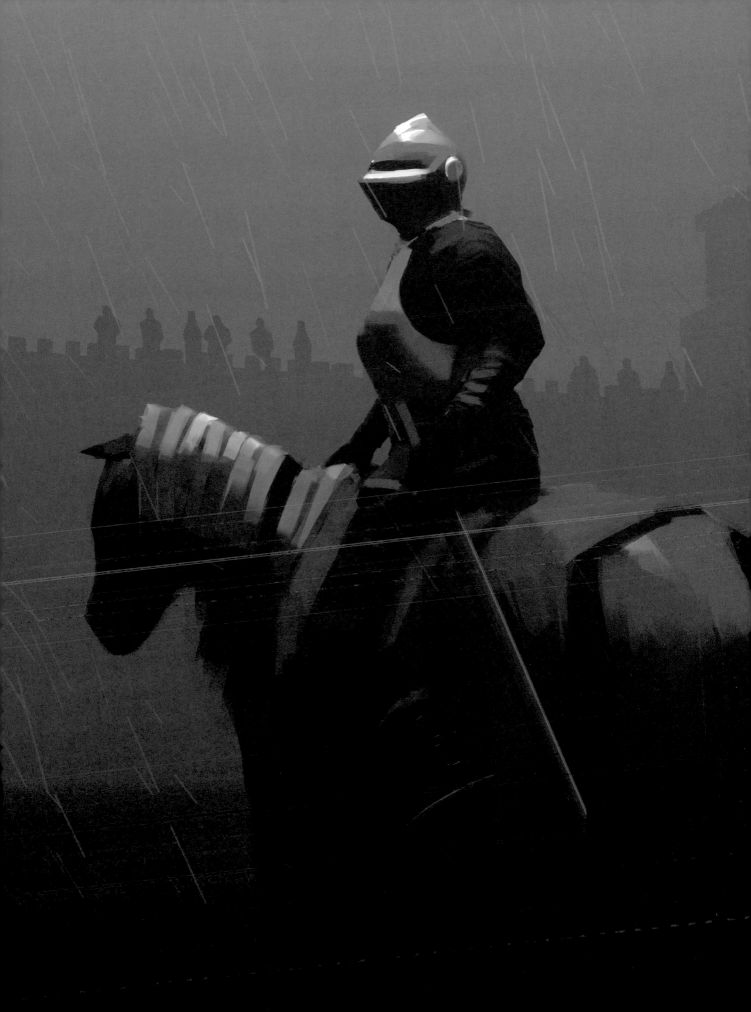

I BROUGHT MY LUTE WITH ME. DOES ANYONE KNOW HOW TO PLAY? I KNOW A FEW SONGS. I WROTE SOME SONGS MYSELF. I DON'T REALLY PLAY THEM IN FRONT OF PEOPLE. I'VE NEVER REALLY SHARED . . . OK, GO ON, I'LL GIVE IT A GO . . . SWEET GODDESS OF THE NIGHT . . . AYYYEEEEEE!

It's quiet times like this around the campfire when you begin to wonder why we ventured into a dungeon that's trying to kill us over and over again . . . almost constantly.

I've heard about these new types of bandages that use crystals to heal your wounds ultrafast.

Is anyone gonna stay up and keep watch, or are we just gonna free ball it?

THAT MAGIC WAND IS SO USEFUL. YOU DON'T NEED TO PACK MATCHES, AND IF YOU NEED ICE CUBES, YOU CAN JUST ZAP 'EM OUT. YOU JUST NEED A DECENT PAIR OF SLACKS AND A MAGIC WAND AND YOU'RE GOOD TO GO.

I never thought I'd say this, but I really miss my Prakarian gerbil. He doesn't love me. But that cute little face. When this dungeon's done and dusted, gonna bring him home some crackers. Speaking of crackers, I have some wafer thins in my sack. I hope they haven't been crushed.

BREATHES IN SMOKE FROM PIPE URGH! *BIG EXHALE AND SIGH* ANOTHER DAY IN THE DUNGEON.

If you think about it, guys, we're doing pretty well so far. I thought our elf friend over here was gonna get eaten by drags and demons, like, at least six times by now.

I'VE GOT SOME FRUIT. WHO'S GOT THE NUTS? UHMMM. BEER, NIGEL?

Feels good to put your feet up and recover those spell slots. Did anyone bring any ham?

There are a few things I wanted to bring up with the group. These are not complaints; these are just things that I wanted to mention, things SOMEONE had to mention. You can't just leave goblin bodies lying around—you have to at least drag them into a hedge. And why am I the only one who brought a map for the mountain section? If I were to misplace mine—I wouldn't—but if I did, then you would all be lost. We need to be thinking of these things at all times, guys. I don't want to be the only one here who's taking responsibility. I've had enough already. I'm done. We're done here.

If anyone starts snoring tonight, I'm gonna get really mad. I haven't slept properly in months.

We should have kept that orc's leg. Unless you guys don't eat orc? Joking . . . you would have told me by now.

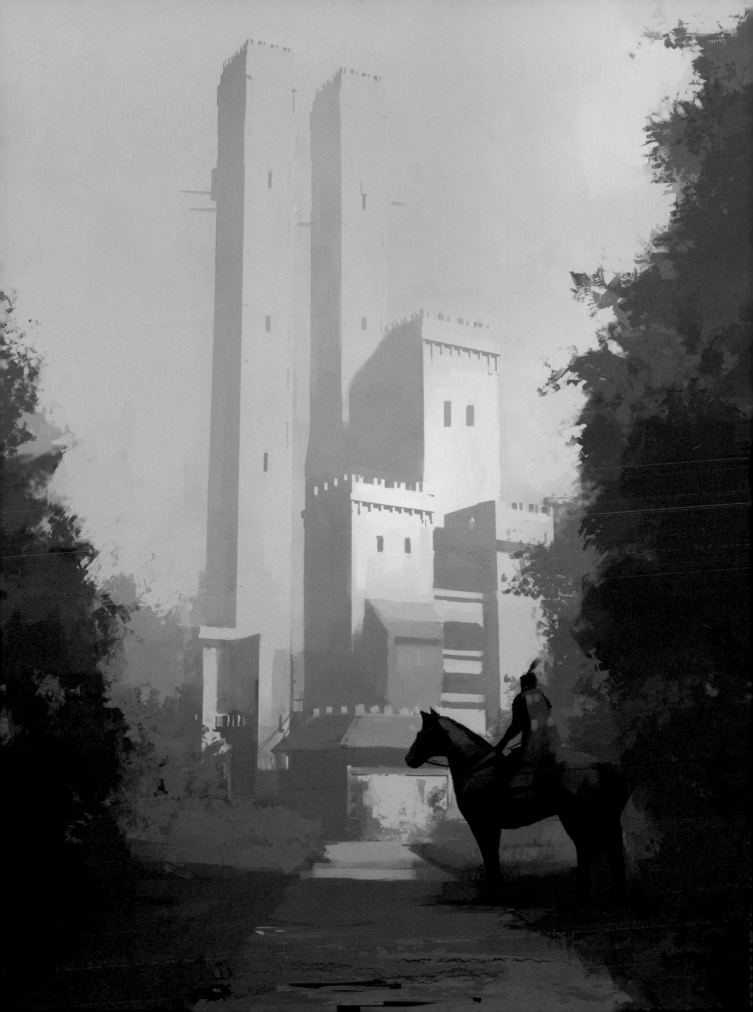

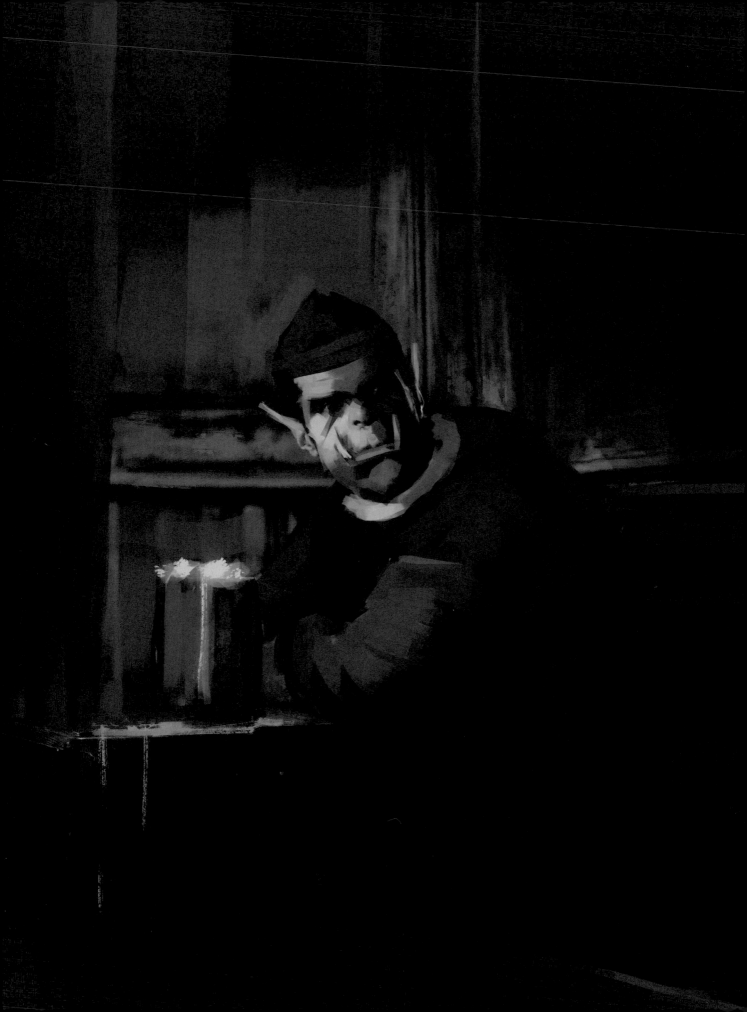

I recovered some gold from that poor orc we found in the depth of the mine. This meal is on our orc friend. *Raises glass* May angels carry you to more fruitful fields.

I COULD EAT A HORSE RIGHT NOW, LADIES. WHO'S WITH ME ON A WHOLE LEG OF THE HORSE? HMM? WHATEVER YOU WANT, LADIES, BUT I'M GETTING ONE.

I feel like this is what the team needed. A work party. A Christmas meal.

What happens in random fantasy adventure bar stays in random fantasy adventure bar.

I hate to be that guy, but this menu has literally nothing that caters to my needs.

I NEED SOMETHING TO SMOKE WITH THIS HAM. YOU, SIR . . . WITH THE TRAY. SOMETHING TO SMOKE, PLEASE.

What is the finest beast you serve in this house? I die for my brothers and sisters. I live for the finest beasts at supper.

I'd like to take a moment to say a few words before we imbibe this fine ale. A short while ago, we decided to form this group and set off on an adventure. I think it's fair to say we all had very different motives—the MacGuffins of our hearts. Now that we have brushed death, now that we have killed together, we have a new purpose: to . . . to . . . stand by each other and to make sure the darkness does not consume us.

I'LL HAVE TWO SHOTS OF YOUR DARKEST EVIL.

WHISPERS WIZARD IS TOTALLY PAYING FOR THIS, RIGHT? I SPENT ALL MY GOLD ON THAT CRAPPY MINE MAP WE DIDN'T USE.

Usually, when I'm in a place like this, I'm worried that someone I know will approach me and ask how things are going. This place is different. I've either flown the nest or entered the fire. Who cares; let's have a drink.

If it's OK with you guys, I'm just gonna kick back with this yogurt tube.

I've never told anyone this before—I tried to start the apocalypse just so I could buy a house.

STEAK! . . . TURKEY STEAK!!!

I LOVE CHAINS. I LOVE THEM. POP A WAKAMAMAHRIA'S ON MY HIGH STREET ANY DAY.

Whispers Guys . . . there's no toilet. Seriously . . . they don't have a bathroom.

You'll wanna stock up on umbrellas after I THROW ALL THIS MONEY AT YOU?!

Take it all. It's not like I need any of it. In fact, my partner will sign you up for an account, and then we won't have to waste any more time.

HERE YOU GO, MY FRIEND. IT'S ALL THERE. YOU KEEP IT STEADY, OK?

If I gave you directions to my people's settlement, would I be able to get any of this delivered?

FIVE STARS FOR YOU. THIS IS ONE HAPPY CUSTOMER.

I came here to make money, not give it all away.

This is ridiculous! You can just get it for free in the other dungeons I've been to!

SOLID GOLD? AND DO I GET IT BACK? LIKE . . . WILL IT SLOWLY GET PAID BACK TO ME?

I would count it for you, but the last time I said six hundred and sixty-six dollars, lots of really messed-up demonic stuff happened. I just wouldn't want that to all go down right in the middle of your store.

IT'S MINE NOW, OR YOU HAVE NO HEAD. SEE THIS SOFT SPOT ON YOUR NECK? EVERYTHING UPWARD OF THAT, TOTALLY GONE FOREVER. YOU WOULDN'T EVER BE ABLE TO PUT IT BACK ON.

Oh, why do you punish me, gods of prosperity?! What have I done to deserve such hardship? WAAAAAAAAAATTTTTTTT?

Elf halfling . . . that six hundred gold we found back there among the ruins . . . that was for all of us, right?

HOW ABOUT WE MAKE A TRADE FOR THIS COLLECTION OF ROCKS? PRETTY HANDY IF YOU HAVE A CATAPULT.

THAT'S CRYPTO FOR YA!

PFFF, I'M NOT PAYIN' FOR THAT.

So you ARE a monster after all.

IS THAT YOU BURNING A HOLE IN MY POCKET OR THE DRAGON-BREATH SPELL OF TAKILLA-KAI-KOOT?

HOW DOES THIS SOUND . . . HALF NOW AND HALF LATER IF THIS ACTUALLY WORKS AND MY CREW AND I ARE STILL ALIVE?

Hey, look . . . I get it . . . we're all just trying to make a living. Slide me down to eighty-five percent, and I'll put in a good word with my nine hundred thousand villager friends.

THIS DUNGEONEERING BUSINESS IS GETTING PRETTY EXPENSIVE!

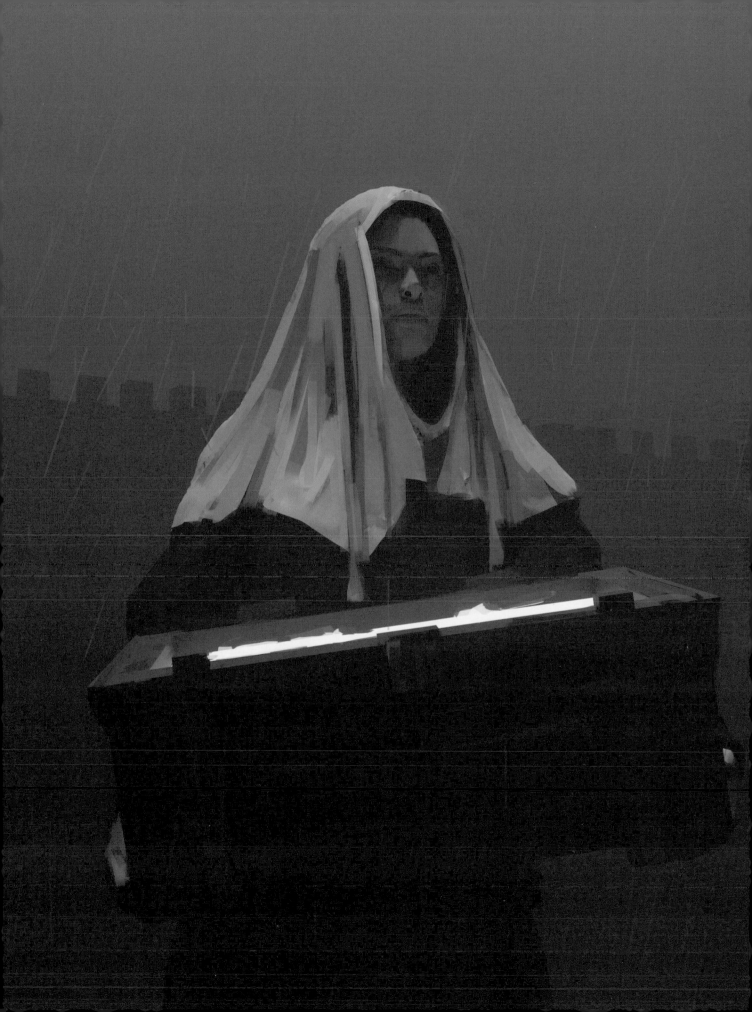

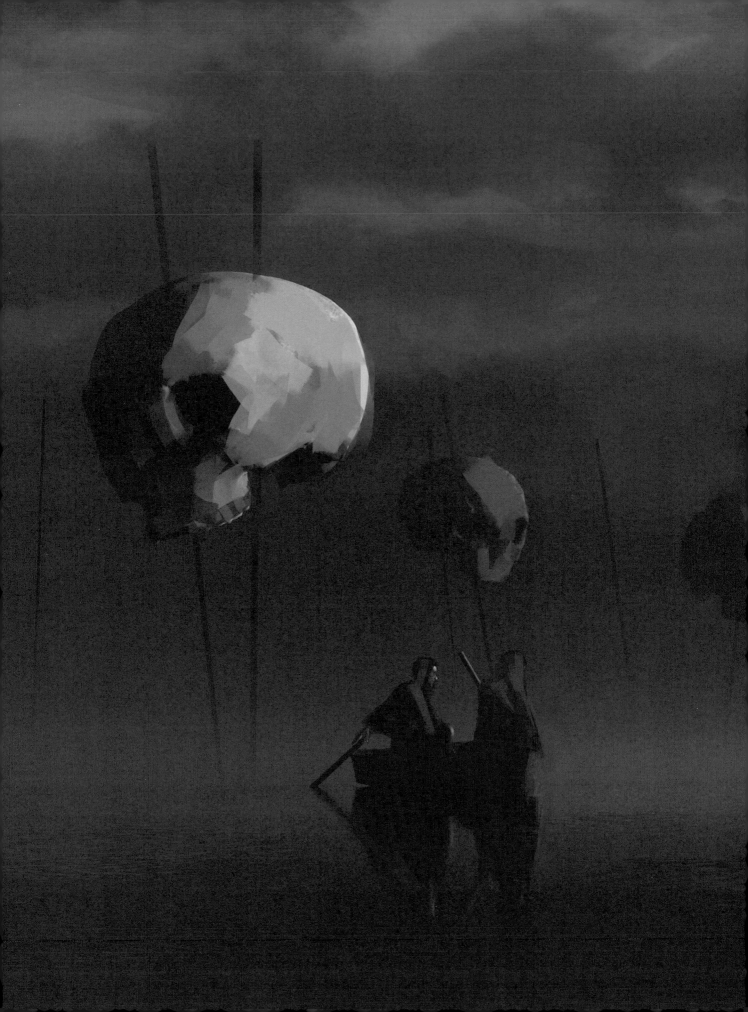

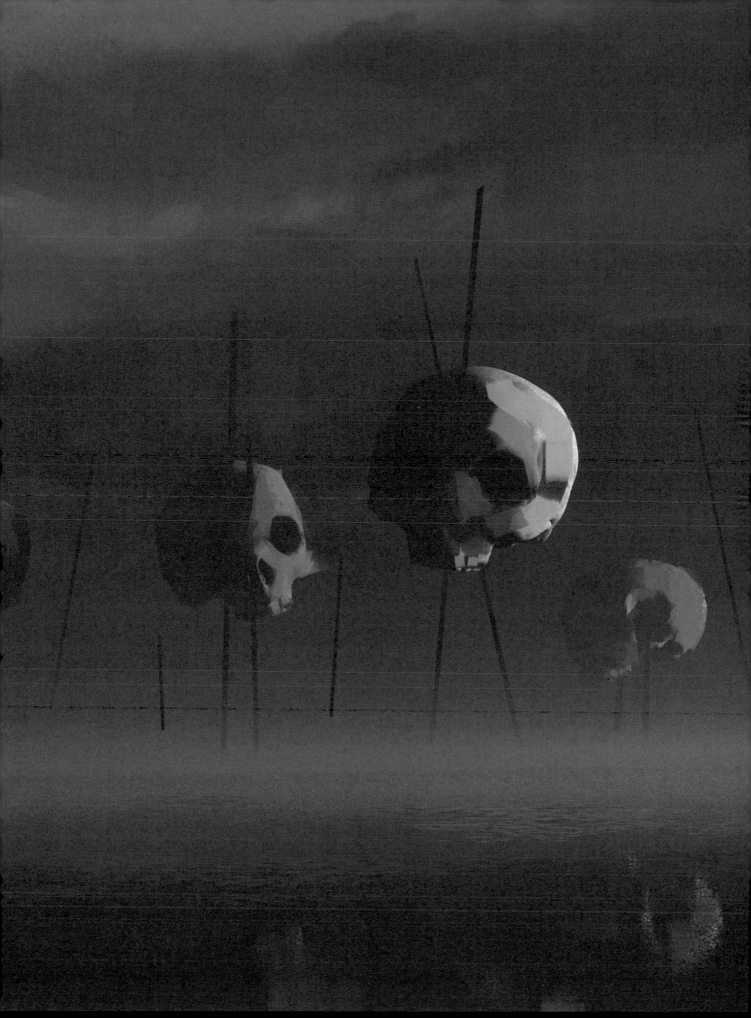

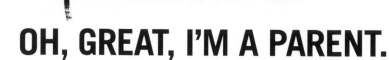

OH, GREAT, I'M A PARENT.

WITH THE LORD AT MY SIDE, I WILL RAISE AND NURTURE THIS CHILD. NO MANNER OF BEAST, SOLDIER, OR WIZARD WILL HARM ME AND MY FAMILY—THE GREAT FIRE THAT DWELLS INSIDE OF ME WILL MAKE SURE OF THAT.

Welcome to the world, my child; it's a strange and unpredictable place.

You guys are gonna help me with this, right?

Woohoo, babies!

Light a fire, and watch it burn. Plant a seed, and watch it grow.

I didn't think miracles ever came true. This precious babe in my arms. This revelation.

Our eternal archetypes cross paths in this plane once more, my sweet offspring.

I'm not ready for this!!! I just want it to go back to the way it was!!!

My uncle and aunt had twelve children. It was a gorgeous family full of love and laughter. It was also, both logistically and financially, totally insane.

Wolfbane of Amatriak, guide me with your wisdom. Draw a new path on this map of life for me and my children.

I don't know what life has in store for you, but I will make sure you feel the warmth before you go.

I never knew my parents, but I am not confused nor conflicted—I am bound with a new love.

BEFORE ANYONE STARTS TO JUDGE ME, NONE OF THIS WAS ON PURPOSE—I DIDN'T DELIBERATELY BECOME A PARENT.

MY SON, IT IS GREAT TO SEE YOUR FACE. YOU WERE BUT A SEED, AND NOW YOU ARE A BEAUTIFUL TREE. EMBRACE ME, YOUR MOTHER, WITH YOUR WHOLESOME GREEN BRANCHES.

WE HAVE BROUGHT LIFE TO THIS DUNGEON—IT SEEMS MINOR IN COMPARISON TO THE DEATH I HAVE DEALT. *CRIES*

I'm concerned that bringing life into this dungeon is comparable to starting a family moments before the apocalypse.

I'm freaking out, you guys. Wasn't I supposed to do classes for sh*% like this? HNNNGGGEEEEEESSSH!

I'M GONNA GET THIS MOMENT PAINTED AND FRAMED.

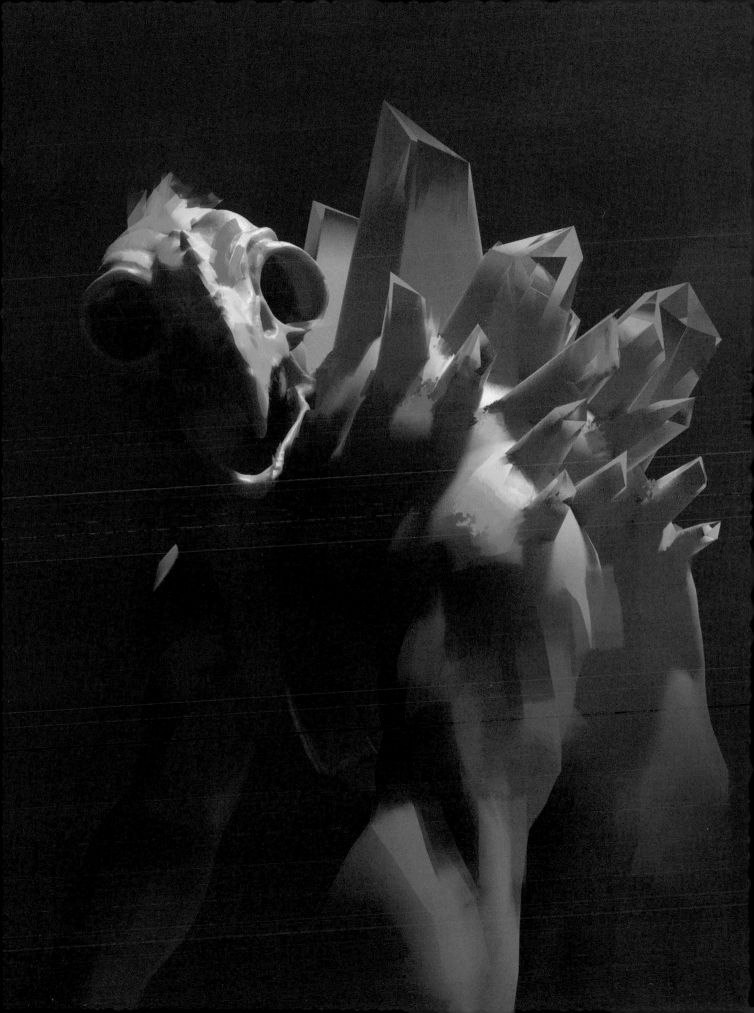

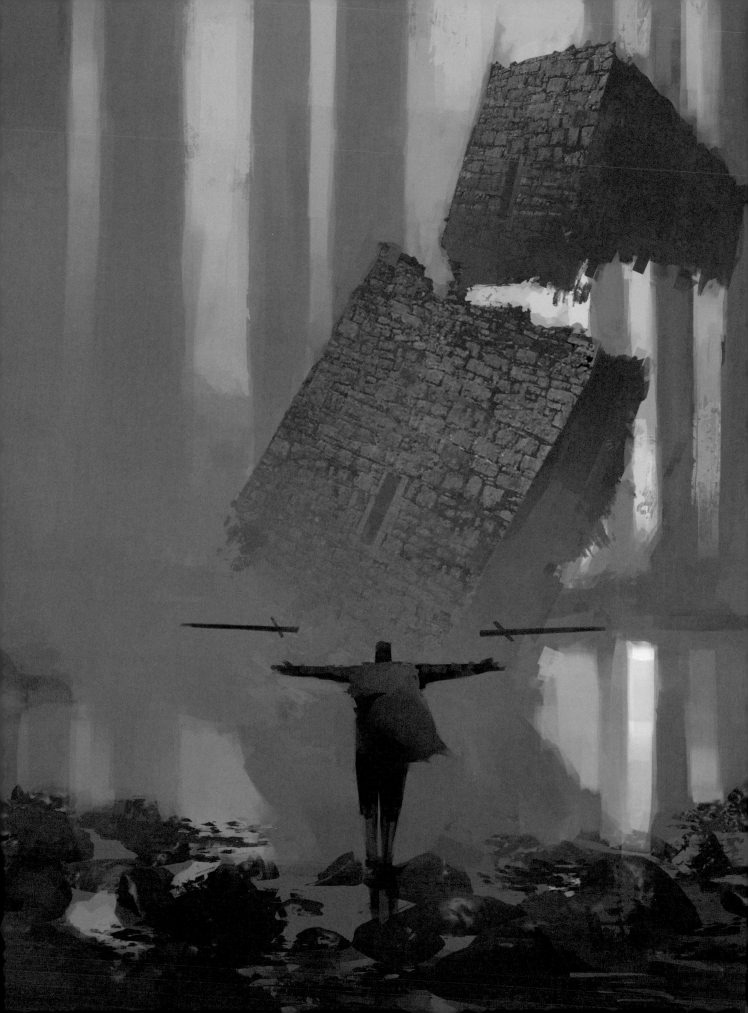

Hey, squad. Do any of you remember when I didn't have superpowers? MWAH HAH HAH HAAAA!

I love having those wizard-like skills even though I never signed up to be a wizard—no need to get jealous, Ted.

I can already feel the darkness consuming me.

BISH, BASH, BOSH, I'M INDESTRUCTIBLE.

Superpowers, superpowers, superpowers. Where were you when I was dating that foreign exchange student?

OH, GREAT, I NO LONGER FEEL EXHAUSTED ALL OF THE TIME.

I didn't ask for this . . . Why would anyone ASK FOR THIS?!

I SHOULD GO BACK TO THOSE THUGS WHO BEAT UP MY OLD LADY AND REALLY TEACH THEM A LESSON.

I breathe in the clouds. The ground now walks on me. And when I fly, the whole world turns.

EVERYTHING I WISHED I WOULD BECOME, I NOW AM.

I worry that history will repeat itself—I'll face off with someone who has similar abilities, and I'll be forced to make a difficult decision or sacrifice. Either way, I'm sure we'll all learn to appreciate everything we had before the powers came along.

OH MY GOD, SOMEONE QUICKLY DRAW A PICTURE OF ME DOING THIS!

THE DAWN OF A NEW ERA. BEG FOR MY MERCY.

Next up on the show is a guy who can lift an entire castle with his mind. Chris, it's a pleasure to meet you. Please tell us all what's been going on with you these past couple of days.

ALL OF THOSE STORIES MY PARENTS TOLD AROUND THE CAMPFIRE, THEY . . . THEY WERE ALL ABOUT ME. I MUST WRITE DOWN ALL OF MY FEELINGS AND REGRETS AND MAIL IT TO THEM. I'M SURE THEY WOULD LOVE TO HEAR FROM ME.

MMMYYYAAAAHHHHOOOOWWWW MUCH CAN YOU LIIIIFFTTT?!!

JUST GONNA GRAB A POT OF TEA, RELAX, AND THEN DO A DEEP DIVE ON ALL THE COOL SH*% I CAN NOW DO.

Now I must think of a good logo that I can burn across my chest.

LOOKS LIKE WE'RE READY TO ROCK, SQUAD. POINT ME IN THE RIGHT DIRECTION, AND I WILL CRUSH.

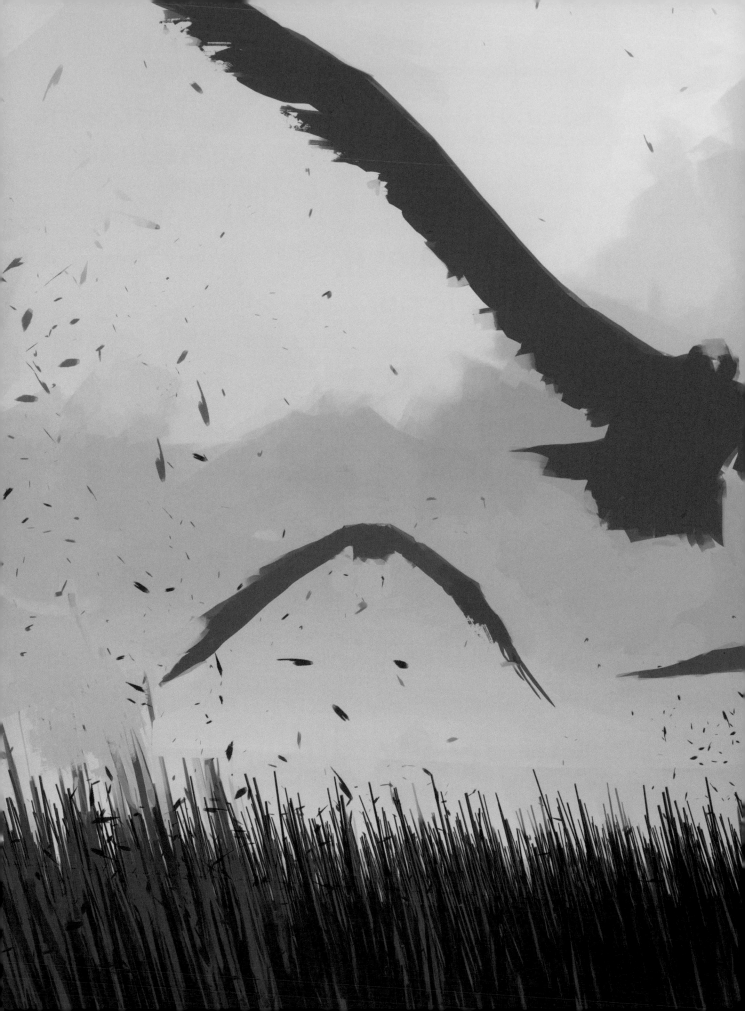

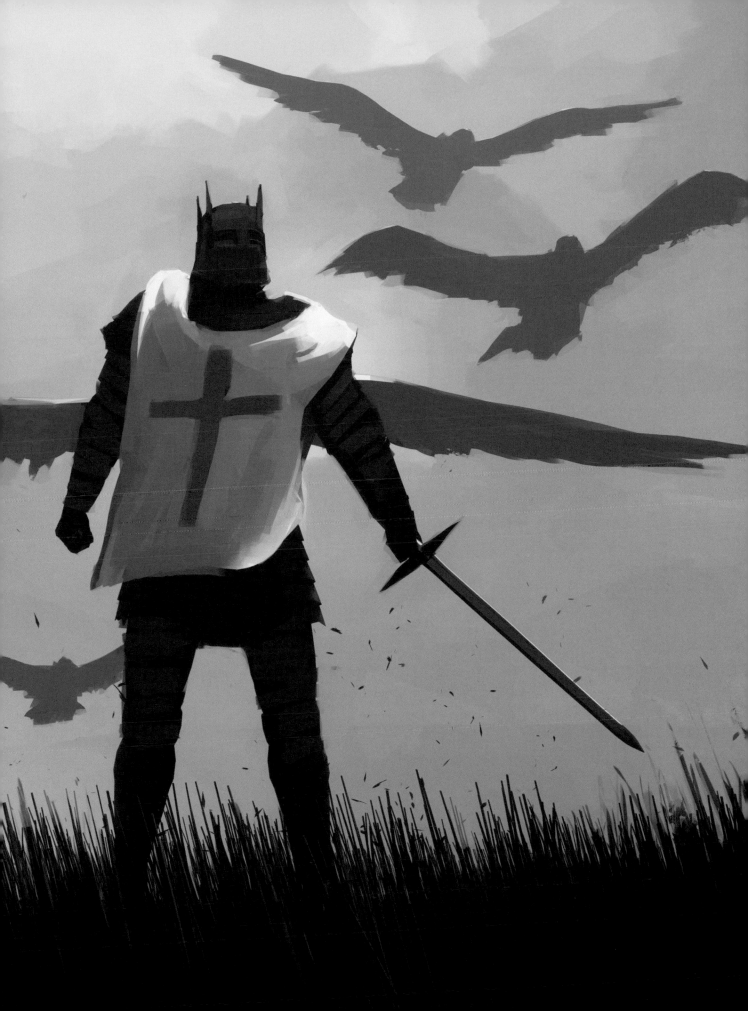

Is this what our quest has come to? Orcs dying in the fields of their own land? Tortured angels burning in cursed skies? What is this war we're fighting? A sacrifice or a grave mistake? When I came to know you, I did not see the darkness that could overcome our purpose. Is it too late to go back to the cool air of spring? Before this fateful summer of haphazard destruction and murder. That gold that lines your pockets, ask yourself, does it now have any value? What is the new cost of our salvation? What is the price of our absolution?

When I was a child, we were told stories of a magic castle. A castle that could grant you many wishes—wishes that could transform your life and the lives of your compatriots. When my friends and I were old enough to leave the village, we went on a journey to find that castle. As the weeks grew longer and more tiresome, we started to feel that this castle only existed in stories. But this place we have before us, it reminds me of that story. Is there something hidden in this dungeon? Is there something magic in this castle?

There are so many things to consider in battle, but if your mind becomes occupied by too many of these considerations, you will be made vulnerable. Do not fight with your words or your mind; fight with your feelings. Fight with your emotions. Let the rhythm guide you. Let your enemy be your dance partner in the cha-cha of death—the macarena of obliteration.

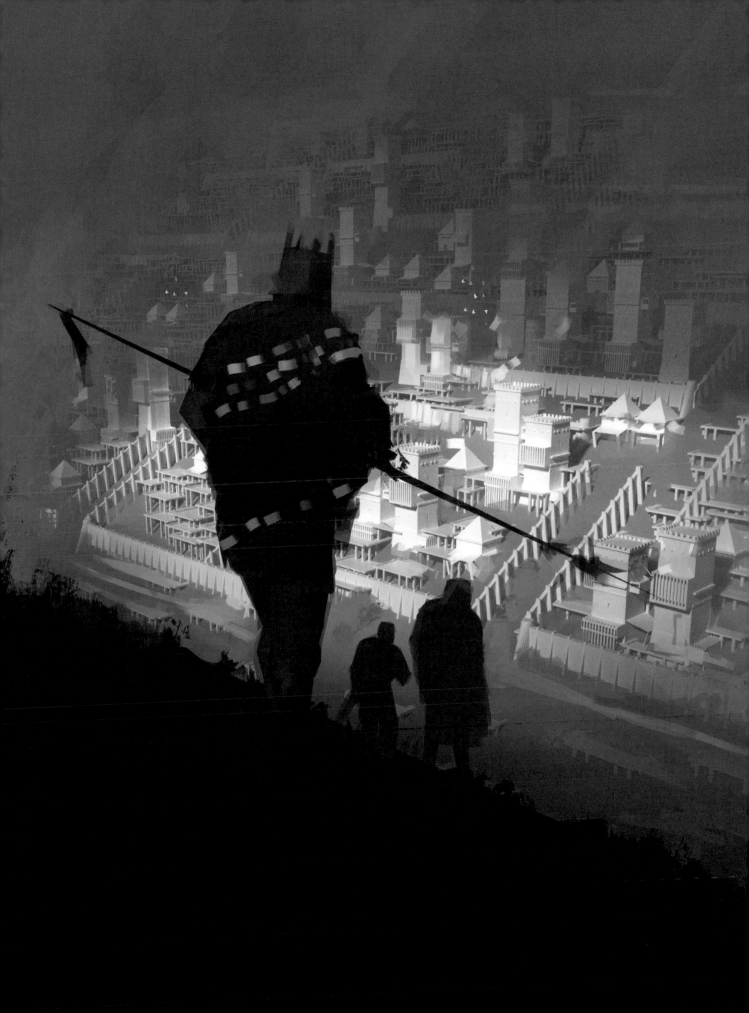

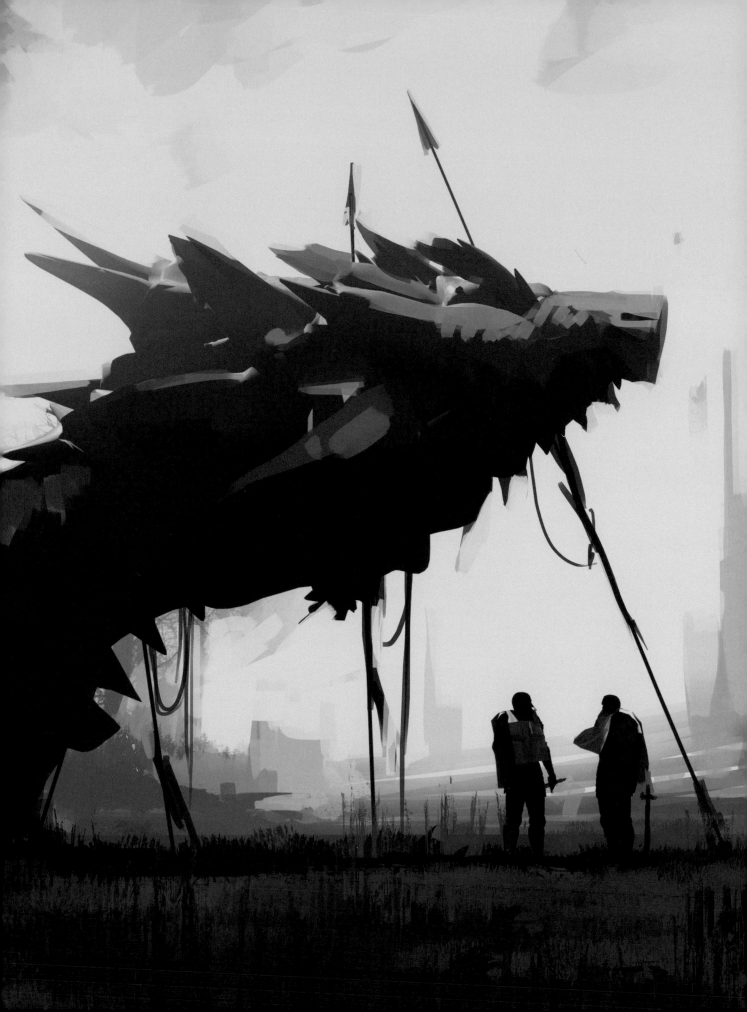

Being attacked by skeletons brings up a lot of bad memories. It's a real sore spot for me and my family. We went camping in the spring, in the hills of Tekrorialah. My father went to the river to get water, and when he walked up to the camp, he was on fire. All of him went up in flames—my whole father. But when he was down to the bone, he was still moving. He desperately thrashed at us, begging us to put the fire out. But it was too late. He left a burn on my cheek. Every morning when I wash my face, I feel his presence—that frail old skeleton wishing he hadn't gone to the river that morning.

I actually had a very close relationship with a group of dragons; they thought of me as one of them. I made spikes on my back and a tail out of old bones. It was a bit like the play *War Horse*—but with a dragon instead of a horse. I would cry at night wishing I could fly like the others, but it wasn't all bad. As I grew up, I began to learn the benefits of being best buds with a league of dragons. A bully punched me in the stomach, then a week later, he was found half eaten along with his close friends and family and also his extended family and in-laws—quite the backup I had with those drags. But those tears. That inability to soar through the skies. In the next life, I pray that I will take my true form and rule alongside the group of dragons that I had a very close relationship with.

No one knew where I came from, who my parents were, or what type of creature or human I was. I didn't care for my mysterious past. I was more preoccupied with the burning of my village, its total destruction, and history repeating itself like every other village I moved to that suffered the same fate. An old wise man told me that I was a bad omen, that this destruction followed me on the same path. I didn't like what he said, so I went back to his cave at night and set fire to his bedroll. What I'm trying to say is this—bad things are going to happen in this dungeon, and bad things have already happened; just don't blame it on me. Unless I start the fire, the burning is just natural—the unpredictability of nature. Anyhow, I could go for some lunch. Has anyone got some flatbread or some cheese sticks?

I'VE ALWAYS SEEN MYSELF AS A LEADER. WHICH ONE OF YOU WOULD LIKE TO BE APPOINTED CHIEF ADVISOR?

***KNEELS TO PRAY* GUIDE US, SACRED SPIRIT. SHOW US THE PATH TO SALVATION.**

Don't look at me. We need to put it to a vote.

The king has returned.

The previous leader was perfectly fine. I say our main focus should be reviving the old leader. Or . . . at least prop him up with sticks.

ALL MY LIFE I HAVE WAITED FOR THIS MOMENT—TO BE CROWNED KING AMONG MY PEERS. THE LEADER OF THE NEW WORLD. THE ICONIC RULER TAKING CHARGE AMID THE DAWN OF A NEW AGE. HNNGGYAHHHHHHHHH!!!!!!

LET'S GO, DADDY-O.

Down this way, guys. Death will embrace us.

It is a pleasure to be nominated leader. In a few hours, I'll give a press conference confirming our next steps, how we can push forward and prepare for all the things that will challenge this group. I've made a suggestion box; just pop your thoughts into there, and they will be reviewed. I've got some tea and cookies at the back of the dungeon.

Please, call me liege.

I've been in this situation before—we head deeper and deeper into the dungeon until we see sunlight. Then, when there is enough room and soft enough ground, we bury the dead.

SIGH OF RELIEF So glad I brought my lucky phylactery.

If you think about it from a different perspective, you could say we're ALL leaders. Right?

I'll be totally honest with you guys; I've been winging it the whole time. If I knew I would be asked to lead the group, I would've dropped out AGES ago.

Years ago, a big, hairy oracle visited my parents. He said that I, their first child, would be nominated leader, but it would be a mistake, and it should totally be someone else.

You want me to lead and also be the first to get attacked when we encounter something. That's the exact opposite of what a leader should be. In fact, let's sacrifice one of you guys right now to show strength.

When I entered this dungeon, I had only two things, a dream . . . and five hundred gold.

Does anyone have a spare wisdom potion? Or a guidance amulet?

If dungeons were all that bad, no one would go dungeoneering. I think we'll be fine.

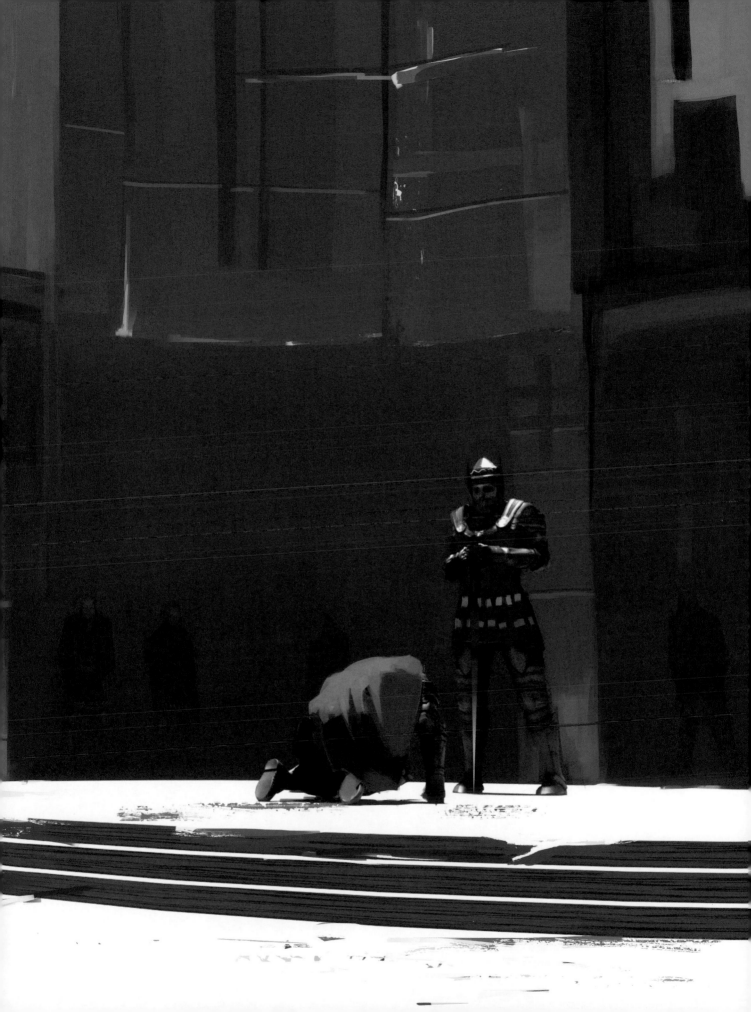

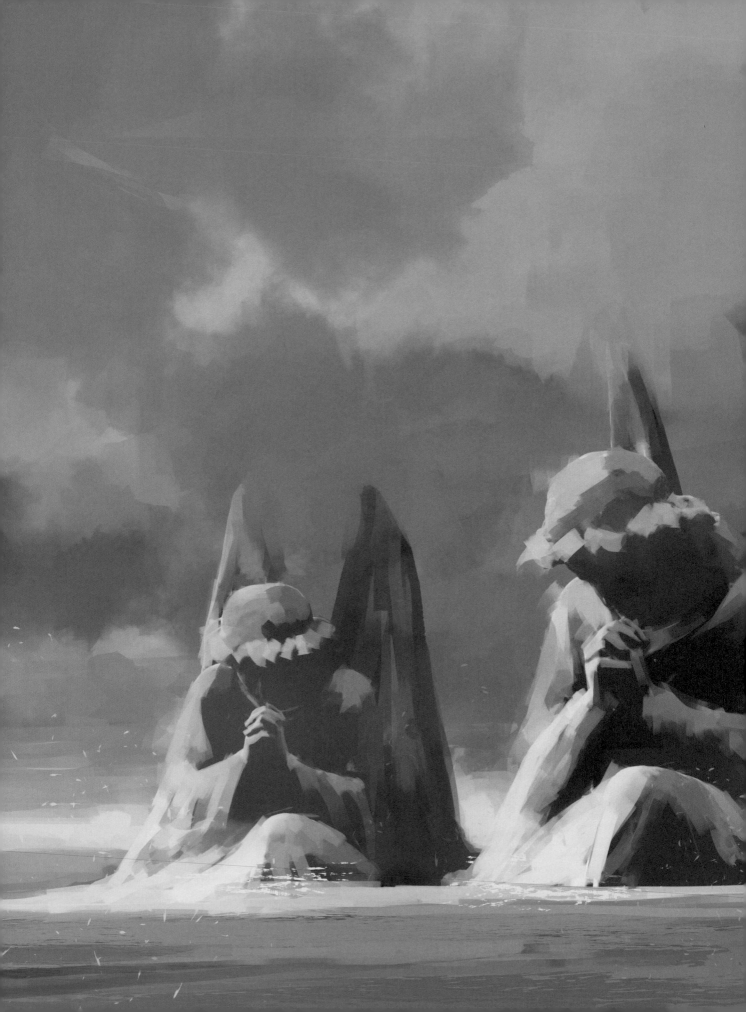

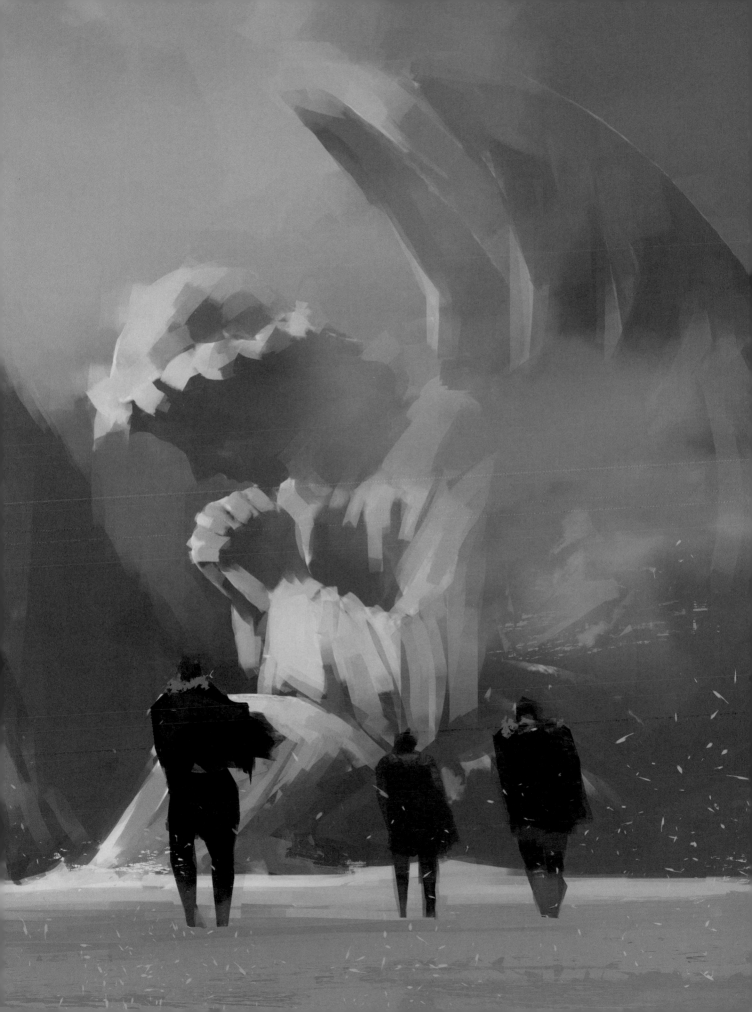

My cousin froze to death on Mount Heraklimia. No one knew why he ventured out that night into the storm. When the villagers recovered his body, they found a collection of highly embarrassing drawings. His legacy of embarrassment did not die on Mount Heraklimia.

THE SISTERS OF MY HOMELAND WOULD REGULARLY SUMMON DEMONS. USUALLY, SOMETHING REALLY MESSED UP WOULD HAPPEN—BUT THERE WAS ALWAYS FIRE INVOLVED. MIGHT HELP US AMIDST THIS GHASTLY SNOWSTORM.

I have no fear. I feel no cold.

BABY, IT'S COLD OUTSIIIIIDE.

I COULD REALLY GO FOR ONE OF THOSE UNDERGROUND LAVA DUNGEONS RIGHT NOW.

Maybe there is no such thing as temperature, and this is all just a demon trying to trick us with his magic.

I wish I'd bought that limited edition dragon-breath spell book now.

It's mighty chilly.

A bowl of warm soup and a fire fit for any fearless adventurer, on our return from this unforgiving chiller.

Y'know, some animals freeze deliberately, and then when things warm up, they defrost and spring back to life. Worth a go, I say, if it means we can skip this frozen hellscape.

Waddle over to my side, brethren. We can use our numbers to survive this cold.

In the hot summer I crave ice-cold drinks and cool breezes. Now I have those in abundance, and I hate it.

I'm worried bits of me are just gonna flake off. No sudden movements, team.

THIS WIND RIPS TO MY CORE. I AM BUT A VAPE AMONG THIS WINTER NATION.

Hey, fellow dungeon dweller. Your last girlfriend. She was pretty cold, aye? Ice-cold queen. Ice-cold quiller writing those frosty letters.

MY GRANDMOTHER WAS A THOUSAND DEGREES COLDER.

It breaks my heart to say this, but I fear we will never leave this place.

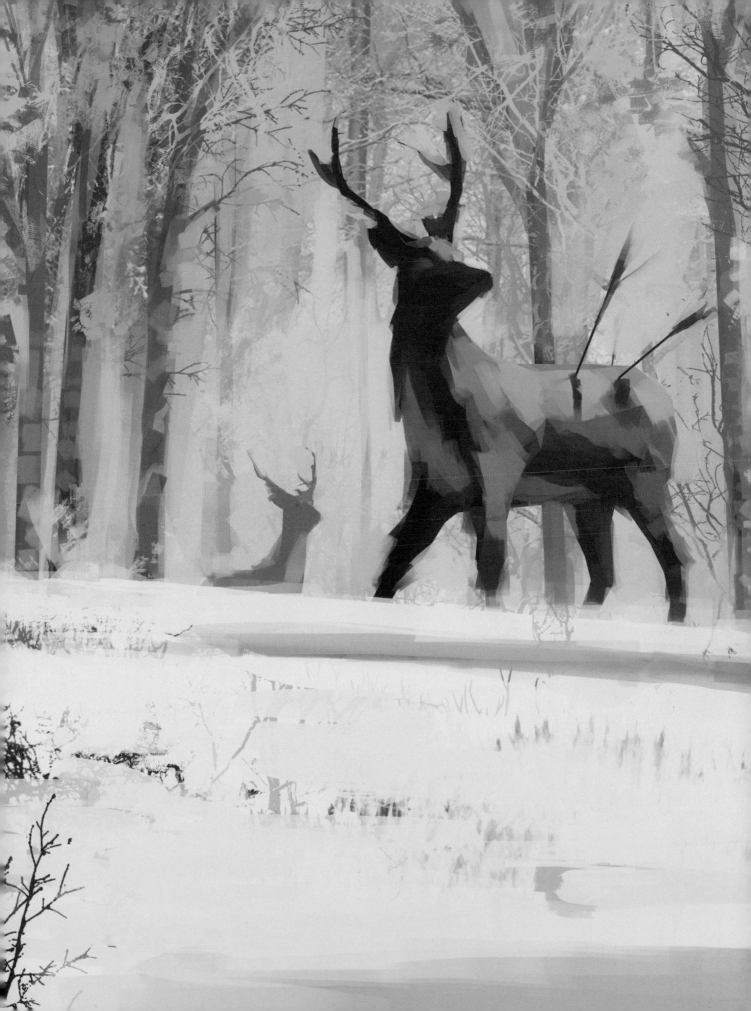

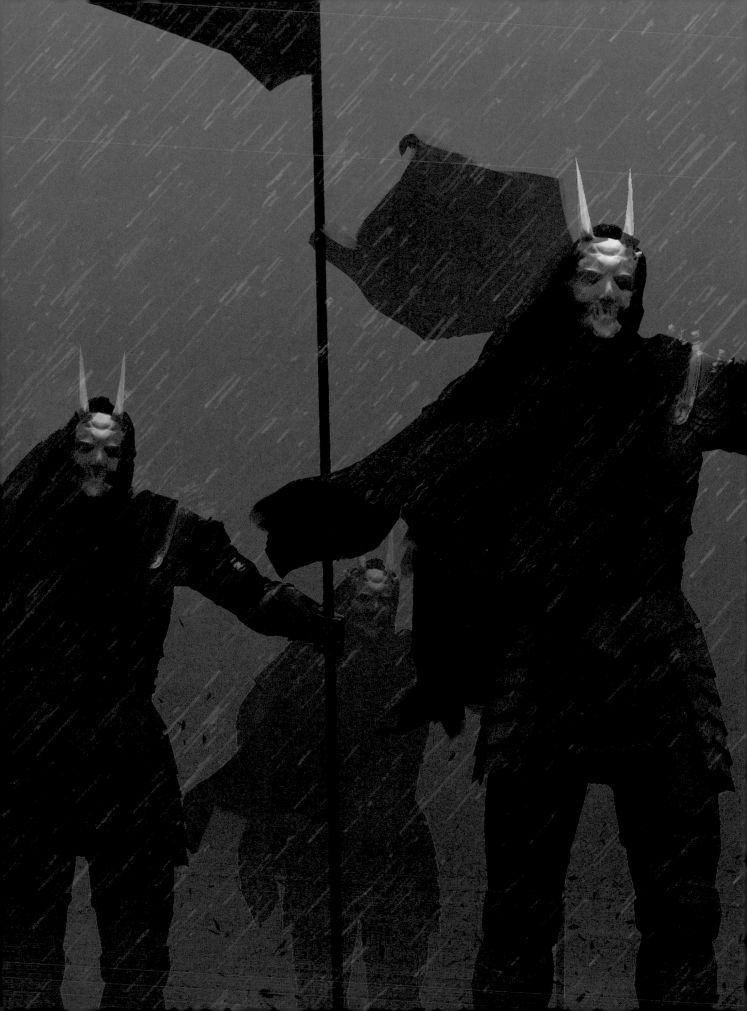

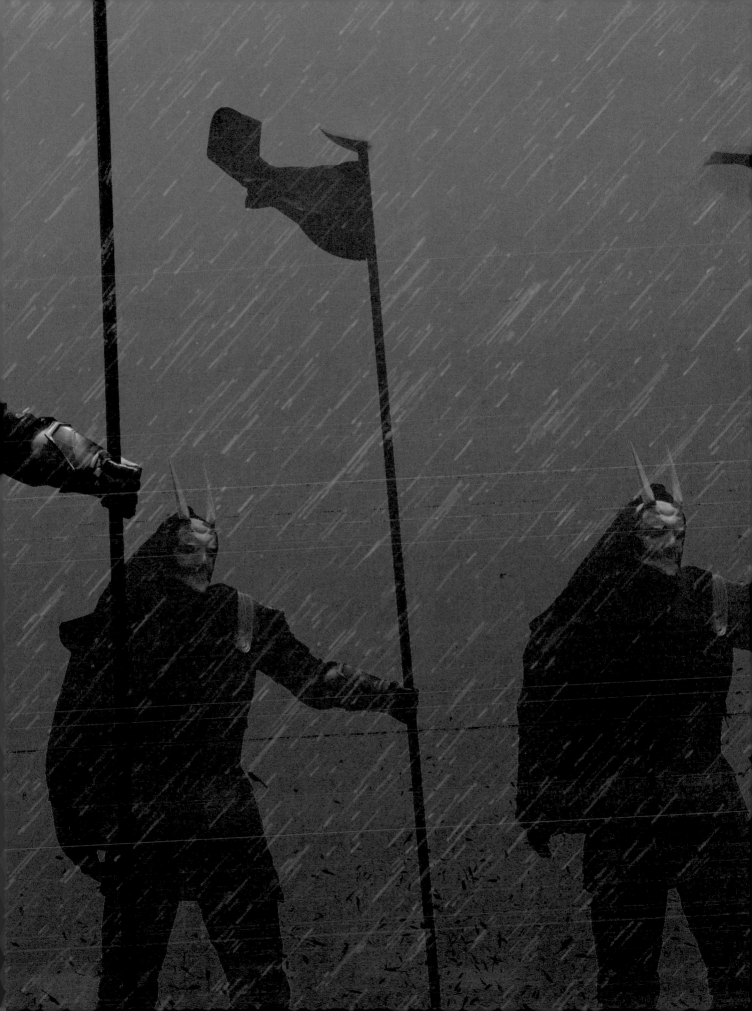

It's nothing a short rest and a cup of tea can't solve.

MY ASCENDANCY IS OUR GREATEST STRENGTH. ONLY MY AX CAN DIVIDE. OBEY, AND YOU WILL PROSPER.

This is what the cave-lord of darkness wanted—to drive a wedge between us. Search for the light inside yourself, the light that guides you, for it is the same burning torch that brought us together.

If I knew we were going to start voting on the decisions I make as leader, I would have thought twice before throwing that dwarf down the hole after taking all his money . . . right in front of you guys.

THIS IS ACTUALLY WHY CUPCAKES WERE INVENTED.

I'm not gonna waste all my spell slots on a dispute that will get us nowhere. Here, take this book—it's one million words that will teach you to forgive and move on. *Jazz hands* Drama!

If we split up, then we have an even smaller chance of making it out alive.

STRIP YOURSELF OF EMOTION. YOUR FEELINGS THAT ARE TRYING TO SURFACE WILL ONLY SERVE TO BETRAY YOU.

As much as we have quarreled, I am bound to you on this quest. You are my sacred chosen allies, the captains of my soul.

Brothers and sisters of the quest, join me in smoking this fine pipe. The pipe gives us release. The pipe gives us union.

Clearly, this is causing some conflict in the group. Let's just draw a line under it right now and find an elf to sacrifice— to pay for any of our recent wrongdoings.

Congratulations, you've successfully split the group in half. Masters of our own fate . . . bye, squad.

I have sought council from my spirit elders. They made it very clear to me, that in all fairness, you totally started it.

GO AND WRITE A SONG ABOUT IT. GET OVER IT. AND THEN COME AND REJOIN US ON THE QUEST.

IF I'M GOING TO MARCH TOWARD DEATH, I'D RATHER DO IT AS A GROUP.

I was joking this whole time. I totally agree with you. Let's go!

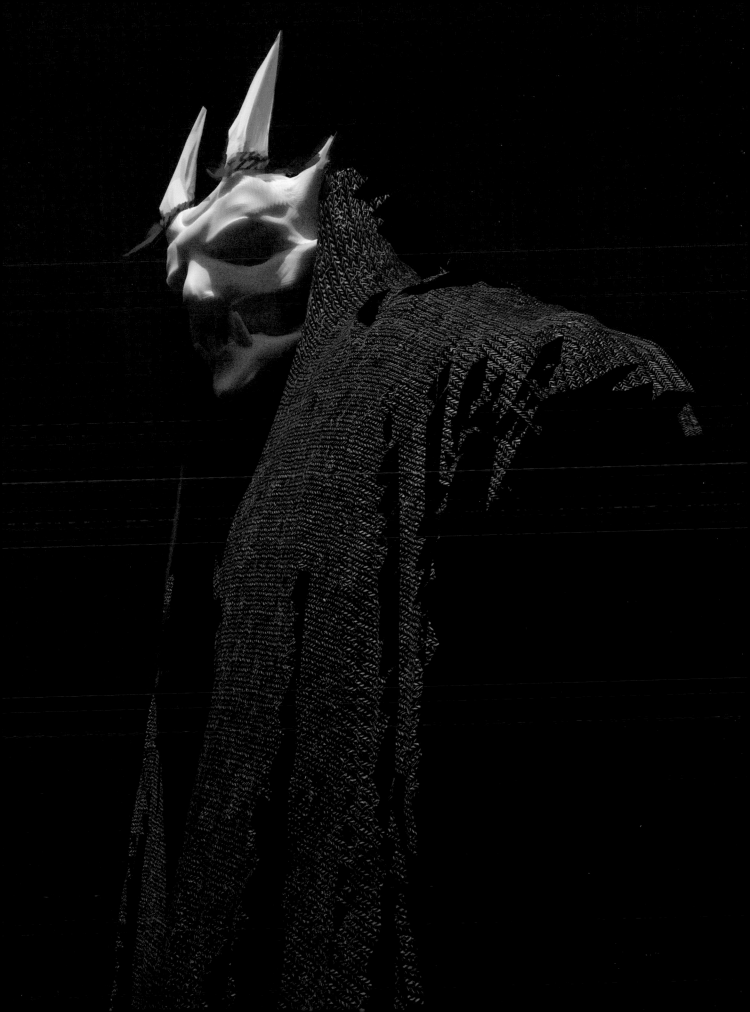

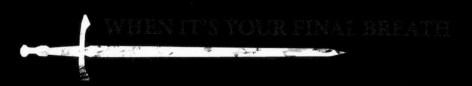

WHAT A PLEASURE IT HAS BEEN. WHAT A BEAUTIFUL FATE.

SAVE MY FAMILY. TELL THEM TO LEAVE FOR GREENER PASTURES.

It's nice to meet you, eternal desolation.

Time to find out who was right, I guess.

Could be worse.

I was good my whole life! That's why I brought my flip-flops and a towel!

I came into this world alone, and alone I shall leave. Oh no, wait! I was a twin! This suucccckssss.

Something's giving me the feeling I'll return in a new form and hit the dungeon again straight off the bat.

HEY, DON'T WORRY, GUYS, I'LL SAVE YOU SOME OF THAT SWEET OJ.

IF I CAN TALK MY WAY OUT OF THIS, I MAY BE ABLE TO AVOID ETERNAL PUNISHMENT.

I CAN HEAR ANGELS SINGING THAT SWEET MORNING HYMN. TRA LA LA LAAAAA . . . LAY MY BLANKET BY THE TREE . . .

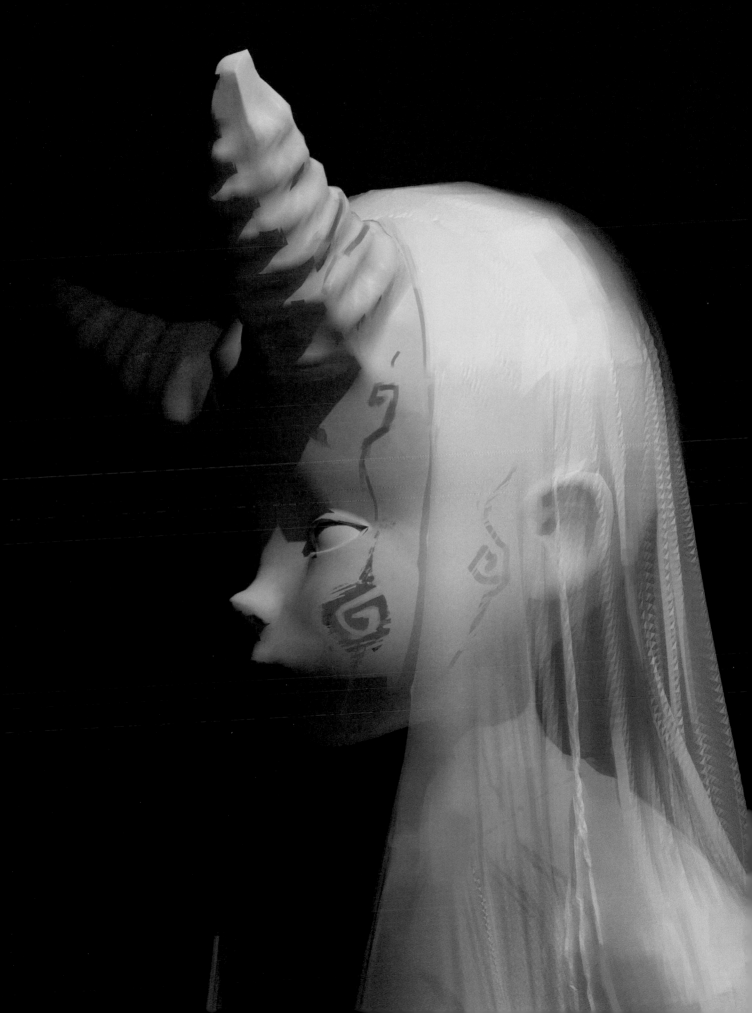

Bryn is a digital painter from South East London. He taught
himself to paint using books and demonstrations on Gumroad.
His clients include various record labels, board game publishers,
and film producers. Bryn also teaches digital painting online.

You can follow Bryn on Instagram at . . .

www.instagram.com/artwithbryn

For art prints, please head over to . . .

www.inprnt.com/gallery/bryngjones

For Bryn's painting tutorials, visit . . .

www.gumroad.com/brynschool or www.patreon.com/brynschool

Andrews McMeel Publishing
a division of Andrews McMeel Universal
1130 Walnut Street, Kansas City, Missouri 64106

www.andrewsmcmeel.com

21 22 23 24 25 SDB 10 9 8 7 6 5 4 3 2 1

ISBN: 978-1-5248-6748-5

Library of Congress Control Number: 2020951550

Editor: Katie Gould
Designer: Sierra S. Stanton
Production Editor: Jasmine Lim
Production Manager: Tamara Haus

ATTENTION: SCHOOLS AND BUSINESSES

Andrews McMeel books are available at quantity discounts with bulk purchase for educational, business, or sales promotional use. For information, please e-mail the Andrews McMeel Publishing Special Sales Department: specialsales@amuniversal.com.